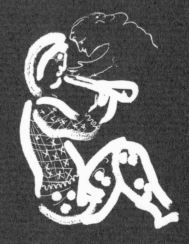

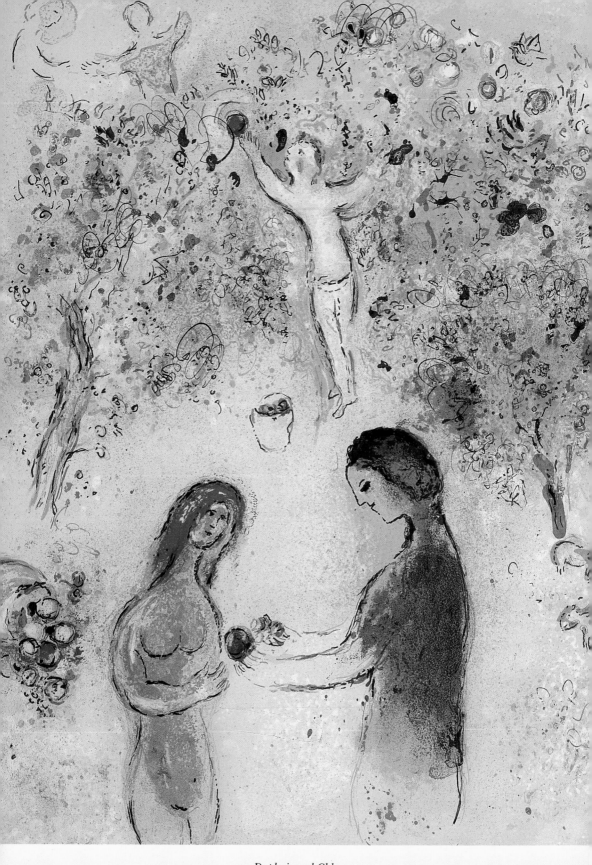

Daphnis and Chloe

Longus

Daphnis and Chloe

with 42 colour plates
after the
lithographs
by

Marc Chagall

Prestel

About This Book

In 1831 Goethe called *Daphnis and Chloe* 'a masterpiece ... in which Understanding, Art, and Taste appear at their highest point, and beside which the good Virgil retreats somewhat into the background ... One would do well to read it every year, to be instructed by it again and again, and to receive anew the impression of its great beauty.' Touching yet humorous, naive and at the same time highly sophisticated, *Daphnis and Chloe* is the story of a shepherd boy and girl who fall desperately in love yet find themselves facing great obstacles, because in their passion they behave, as the author says, even more awkwardly 'than rams and ewes.'

This sole surviving bucolic novel of ancient Greek origin was written by Longus, a poet about whom nothing else is known, and dates to about the mid third century A. D. The lyrical beauty and sensual frankness of the story have found admirers from Shakespeare to Jacob Burckhardt, and have exerted lasting influence on European literature. It was not until 1810 that the first complete manuscript of *Daphnis and Chloe* was discovered, in Florence. This provided the basis for the present, superb translation, done in 1956 by Paul Turner.

Marc Chagall's illustrations to the pastoral tale, which is set on the island of Lesbos, were inspired by his first-hand experience of Greece. His lithographs combine the Mediterranean lushness of the realm of Pan and Eros with memories of Russian Jewish folktales, and celebrate the lovers in a setting whose marvels of colour evoke Eden with a sumptuousness that is inimitably Chagall. Art of the highest order united with poetry of timeless appeal – the result is an irresistibly delightful book.

CONTENTS

CHARACTERS

Daphnis and Chloe

Lamon and Myrtale	*Foster-parents of Daphnis*
Dryas and Nape	*Foster-parents of Chloe*
Dionysophanes and Cleariste	*Parents of Daphnis*
Astylus	*Brother of Daphnis*
Gnathon	*A parasite around Astylus*
Eudromus and Sophrosyne	*Members of the household of Dionysophanes*
Megacles and Rhode	*Parents of Chloe*
Dorcon, Lampis, Philetas	*Cowherds*
Tityrus	*Son of Philetas*
Amaryllis	*Lover of Philetas*
Chromis and Lycaenion	*A farmer and his wife*
Bryaxis	*Methymnean general*
Philopoimen and Agelaia	*Children of Daphnis and Chloe*

Prologue

WHEN I was hunting in Lesbos, I saw, in a wood sacred to the Nymphs, the most beautiful thing that I have ever seen – a painting that told a love-story. The wood itself was beautiful enough, full of trees and flowers, and watered by a single spring which nourished both the flowers and the trees; but the picture was even more delightful, combining excellent technique with a romantic subject. It had become so famous that crowds of people used to go there even from abroad, partly to pray to the Nymphs, but mainly to see the picture. In it there were women having babies and other women wrapping them in swaddling clothes, babies being exposed, sheep and goats suckling them, shepherds picking them up, young people plighting their troth, pirates making a raid, enemies starting an invasion.

After gazing admiringly at many other scenes, all of a romantic nature, I was seized by a longing to write a verbal equivalent to the painting. So I found someone to explain the picture to me, and composed a work in four volumes as an offering to Love and the Nymphs and Pan, and as a source of pleasure for the human race – something to heal the sick and comfort the afflicted, to refresh the memory of those who have been in love and educate those who have not. For no one has ever escaped Love altogether, and no one ever will, so long as beauty exists and eyes can see. But as for me, I hope that the god will allow me to write of other people's experiences, while retaining my own sanity.

First Book

THERE is in Lesbos a large and beautiful city called Mytilene. It is intersected by canals, where the sea flows inland, and decorated with bridges of polished white stone. You will think, when you see it, that it is not so much a city as an island. Well, about twenty-two miles from this city of Mytilene was an estate belonging to a certain rich man. It was a very fine property, including mountains that supplied game, plains that produced wheat, hillsides covered with vines, and pastures full of flocks. There was also a long beach, against which the waves used to break with a soft bewitching sound.

While grazing his flock on this estate a goatherd called Lamon found a baby being suckled by one of his she-goats. There was a small wood containing a bramble-thicket, some wandering ivy, and some soft grass on which the baby was lying. The goat kept running out of sight in this direction and deserting her kid in order to stay beside the baby. Lamon noticed her running to and fro, and felt sorry for the neglected kid, so although it was the hottest time of day he went off after her and this is what he saw: the goat was standing cautiously astride the baby, so as not to hurt it by treading on it with her hooves, and the baby was sucking away at her milk just as if it came from its mother's breast. Naturally he was astonished; so he went up close and found that it was a boy – a fine big one, and better dressed than foundlings usually are, for it had a little cloak dyed with genuine purple, a golden brooch, and a dagger with an ivory hilt.

His first plan was to ignore the baby and merely go off with the tokens of its identity. But then he felt ashamed to show less humanity than a goat, so he waited until it was dark and took the

9

whole lot home to Myrtale, his wife – tokens, baby, goat and all. Myrtale was astonished at the idea of goats having babies – until he told her the whole story, how he had found the child exposed, how he had seen it being suckled, and how he had been ashamed to leave it to die. She felt the same as he did, so they hid the things that had been left with the baby, called it their own child, and gave the job of nursing it to the goat. And to ensure that the child's name should sound adequately pastoral, they decided to call him Daphnis.

Two years went by and a shepherd in the neighbouring fields whose name was Dryas found and saw something very similar. There was a cave sacred to the Nymphs which consisted of a great rock, hollow inside and rounded outside. The images of the Nymphs themselves were made of stone. Their feet were bare, their arms were naked to the shoulder, and their hair hung down loose over their necks. They had girdles round their waists and smiles on their faces; and their whole attitude was suggestive of dancing. The mouth of the cave was in the very middle of the rock, and from it water came gushing out and flowed away in a stream; so there was an expanse of very lush-meadow in front of the cave, as the moisture made the grass grow thick and soft. Hanging up in the cave were milk-pails and transverse flutes and Pan-pipes and reed-pipes, the offerings of sheperds in bygone days.

A ewe which had recently lambed kept going into this sanctuary of the Nymphs and several times made Dryas think she was lost. So wishing to punish her and get her back into good habits, he twisted a green switch into a halter like a snare and went off to the rock in the hope of catching her there. But when he arrived he did not see at all what he expected. He saw the ewe behaving just like a human being – offering her teats to the baby so that it could drink all the milk it wanted, while the baby, which was not even crying, greedily applied first to one teat and then

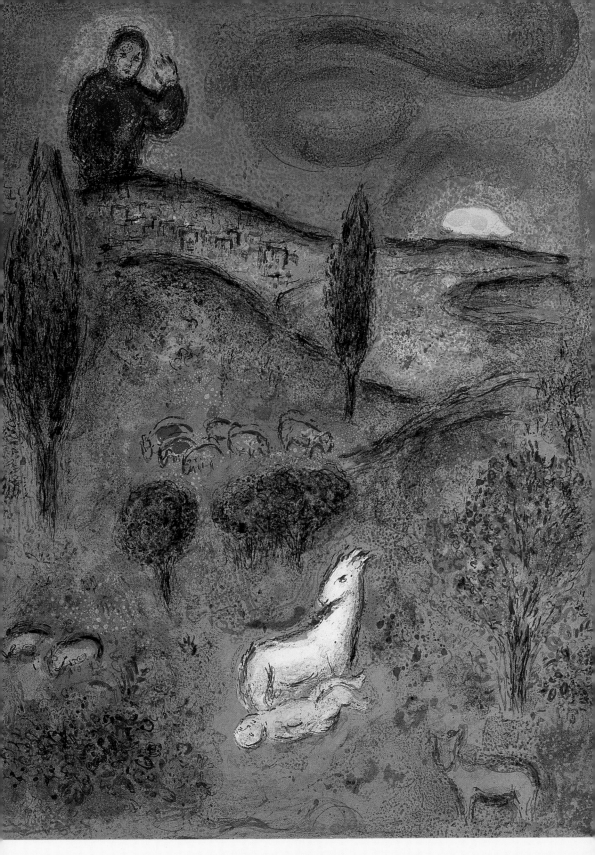

Lamon Finds Daphnis

to another a mouth shining with cleanliness, for the ewe was in the habit of licking its face with her tongue when it had had enough. This child was a girl; and like the other it had tokens lying beside it – a girdle woven with gold thread, a pair of gilded sandals, and some anklets of solid gold.

Thinking that the gods must have had a hand in this discovery and taught by the ewe's example to pity the child and love it, he took the baby up in his arms, stowed away the tokens in his knapsack, and prayed to the Nymphs to give him good luck in return for bringing up their *protégée*. When it was time to drive the flock back, he went home to his cottage, described to his wife what he had seen, showed her what he had found, and told her to treat the baby as her daughter and bring it up as if it were her own, without letting anyone know the truth. So Nape (for that is what she was called) immediately began to mother the child and love it, for fear of being outdone by the ewe. And to make the thing convincing, she too gave the child a pastoral name, Chloe.

These children grew up very quickly and were noticeably better-looking than ordinary country people. And now Daphnis was fifteen years old, and Chloe two years younger, when in the course of a single night both Dryas and Lamon had dreams that went something like this. They dreamt that the Nymphs – the ones in the cave with the spring in it, where Dryas had found the baby – were handing Daphnis and Chloe over to a very autocratic and very beautiful small boy who had wings growing out of his shoulders and carried tiny arrows and a tiny bow. This boy hit both of them with a single arrow, and gave orders that Daphnis should in future be a goatherd, and Chloe a shepherdess.

Their first reaction to this dream was disappointment, to think that the children were to be ordinary shepherds and goatherds after all, when the tokens had seemed to promise better things – for which reason they had been given especially good food, and taught to read and write and do all the things

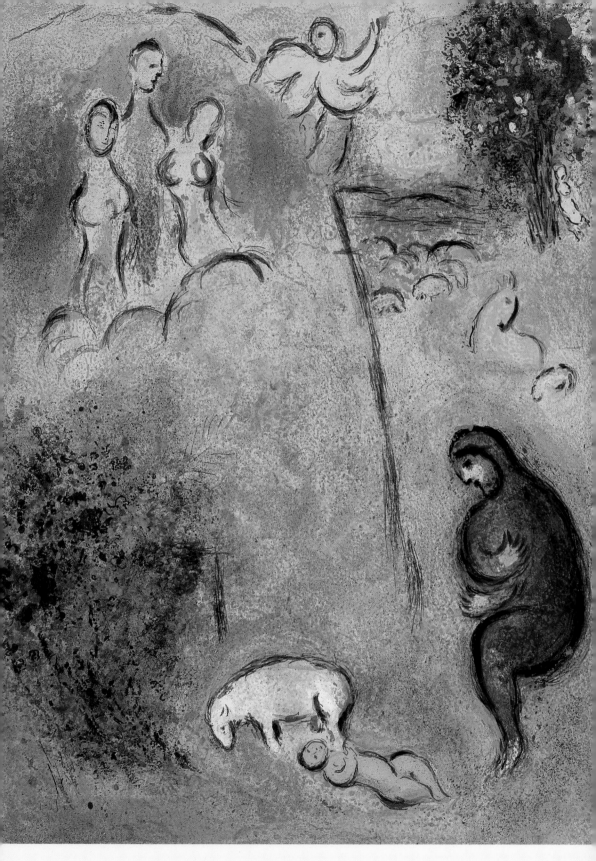

Dryas Finds Chloe

that were regarded as great accomplishments in the country. But then it seemed best to accept divine guidance in the case of children whose very survival had been due to divine providence.

So when Dryas and Lamon had told each other their dreams, and made a sacrifice in the presence of the Nymphs to 'the winged boy' (for they did not know his name), they sent Daphnis and Chloe out as shepherds with their flocks, after giving them minute instructions about how to graze the animals before noon, and how to graze them when the heat of the day was over; when to drive them to water, and when to drive them back to the fold; which of them they would have to use a stick on, and which of them they could control by the voice alone. So Daphnis and Chloe took over their new job with as much satisfaction as if it had been a great command, and grew fonder of the goats and the sheep than herdsmen usually are, since Chloe was aware that she owed her life to a sheep, and Daphnis remembered that when he was exposed a goat had suckled him.

It was the beginning of spring and all the flowers were in bloom, in the woods, in the meadows, and on the mountains. Already there was a buzzing of bees, there was a sound of singing-birds, there were gambollings of new-born lambs. The lambs were gambolling on the mountains, the bees were buzzing in the meadows, and the birds were filling the thickets with enchanting song. So now that all things were possessed by the beauty of the season, these two tender young creatures began to imitate the sights and sounds around them. Hearing the birds singing they burst into song, seeing the lambs gambolling they danced nimbly about, and taking their cue from the bees they started gathering flowers, some of which they dropped into their bosoms, and the rest they wove into garlands to hang on the images of the Nymphs.

They did everything together, for they grazed their flocks

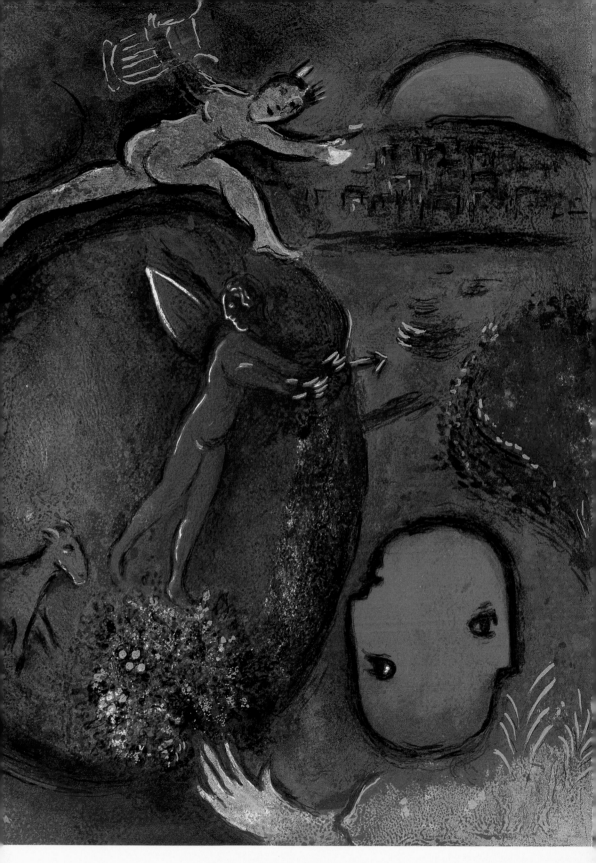

The Dream of Lamon and Dryas

side by side; and often it would be Daphnis who rounded up the sheep that had strayed, and Chloe who drove down the more adventurous goats from the high rocks. In fact it sometimes happened that one of them would look after both the flocks, because the other was busy playing with some toy.

Their toys were of a pastoral and childish nature. Chloe would go off somewhere and pick up some stalks of corn which she would weave into a cage for a locust; and while she was working on it she would forget about the sheep. And Daphnis, after cutting some slender reeds, piercing them at the joints, and fastening them together with soft wax, would practise playing the Pan-pipe until it was dark. Sometimes too they would share the same drink of milk and wine, and divide between them all the food that they brought from home. Altogether, you would have been more likely to see the sheep or the goats separated from one another, than Chloe separated from Daphnis.

While they were playing like this, Love made something serious flare up. A she-wolf with young cubs to feed had been carrying off a great many animals from other flocks in the neighbouring fields, as she needed a great deal of food to rear her cubs. So one night the villagers got together and dug some pits about six feet wide and twenty-four feet deep. Most of the soil that had been dug up was carted away and scattered a long way off; but over the mouth of each pit they placed long pieces of dry wood and sprinkled the rest of the soil on top, to make the ground look the same as before. So even a hare running across it would have broken the pieces of wood, which were no stronger than twigs, and would then have realized that it was not solid earth after all, but a mere imitation of it. They dug several pits like this both on the mountains and in the plains, and never succeeded in catching the wolf, for she realized that the ground had been tampered with; but they managed to kill a great many goats and sheep, and they came very near to killing Daphnis.

It happened like this. Some he-goats got angry and started to fight. They came together rather violently, with the result that one of them had one of his horns broken and ran away snorting with pain. But the victor followed him closely and kept him on the run. Feeling upset about the broken horn and annoyed at such unruly behaviour, Daphnis began pursuing the pursuer with a stick. Since the goat was intent on getting away, and the boy was angrily intent on catching him, neither was very careful to look where he was going and they both fell into a pit – first the goat, and then Daphnis. In fact the only thing that saved Daphnis's life was using the goat to break his fall.

So Daphnis waited in tears for someone to pull him out – if anyone was ever going to. But Chloe, who had seen the whole thing, came running to the pit and finding that Daphnis was alive called a cowherd in a neighbouring field to come and help. When he arrived he started looking for a long rope for Daphnis to hold on to, so as to be pulled out; and there was no rope to be found. But Chloe untied her breastband and gave the cowherd that to let down. So they stood on the edge of the pit and pulled, while Daphnis clung to the breastband with both hands and came up with it. They also pulled up the wretched goat, with both his horns broken – so quickly had the vengeance of the conquered he-goat overtaken him. He was only fit for slaughter, so they gave him to the cowherd as a reward for life-saving, and prepared to make up a story about an attack by wolves, in case anyone at home noticed that the goat was missing. Then they went back to find out how the rest of the goats and sheep were getting on.

Having made sure that both the sheep and the goats were grazing properly, they sat down against the trunk of an oak and looked to see if Daphnis had got blood on any part of his body as a result of his fall. There was no sign of a wound and no trace of blood, but his hair and the rest of his body were plastered

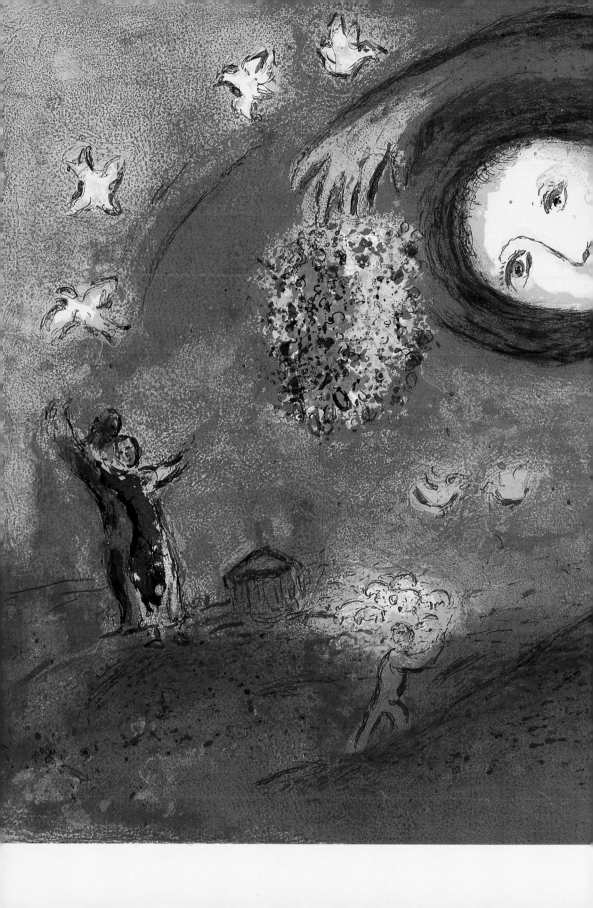

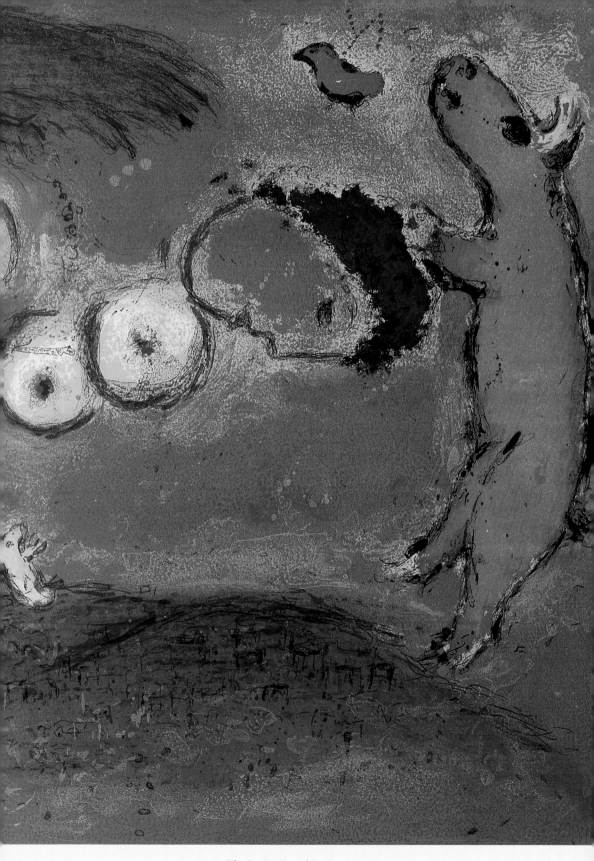

The Beginning of Spring

with loose earth and mud; and it seemed best for him to wash before Lamon and Myrtale found out what had happened.

So he went off with Chloe to the sanctuary of the Nymphs, where he gave her his shirt and knapsack to look after, while he stood in front of the spring and started washing his hair and his whole body. His hair was black and thick, and his body was slightly sunburnt – it looked as though it was darkened by the shadow of his hair. It seemed to Chloe, as she watched him, that Daphnis was beautiful; and as he had never seemed beautiful to her before, she thought that this beauty must be the result of washing. Moreover, when she washed his back, she found that the flesh was soft and yielding; so she secretly touched her own body several times to see if it was any softer. Then, as the sun was setting, they drove their flocks home, and nothing out of the ordinary had happened to Chloe except that she had set her heart on seeing Daphnis washing again.

When they got to the pasture next day, Daphnis sat down under the usual oak and began to play his pipe. At the same time he kept an eye on the goats, which were lying down and apparently listening to the music. Chloe sat beside him and kept watch over her flock of sheep; but most of the time she was looking at Daphnis. While he was piping he again seemed to her beautiful, and this time she thought that the beauty was caused by the music; so when he had finished she picked up the pipe herself, in the hope that she too might become beautiful. She also persuaded him to have another wash; and while he was washing she looked at him, and after looking at him she touched him. And again she went away full of admiration, and this admiration was the beginning of love.

She did not know what was wrong with her, for she was only a young girl who had been brought up in the country and had never even heard the word 'love' used by anyone else. But she felt sick at heart, and she could not control her eyes, and she was

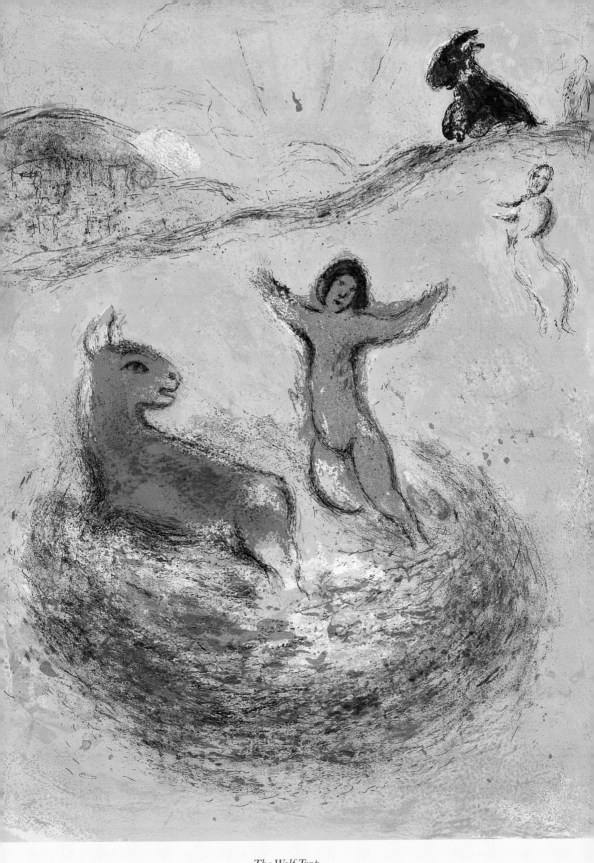

The Wolf Trap

always talking about Daphnis. She took no interest in food, she could not sleep at night, she paid no attention to her flock. One moment she would be laughing, the next she would be crying. Now she would be lying down, now she would be jumping up again. Her face would grow pale, and then grow fiery red. In fact cows that have been stung by gadflies behave less oddly than she did.

One day when she was alone she found herself talking like this: 'There's something wrong with me these days, but I don't know what it is. I'm in pain, and yet I've not been injured. I feel sad, and yet none of my sheep have got lost. I'm burning hot, and yet here I am sitting in the shade. How often I've been scratched by brambles and not cried! How often I've been stung by bees and not screamed! But this thing that's pricking my heart hurts more than anything like that. Daphnis *is* beautiful, but so are the flowers. His pipe does sound beautiful, but so do the nightingales – and I don't worry about them. If only I *were* his pipe, so that he'd breathe into me! If only I were a goat, so that I could have him looking after me! You wicked water, you made Daphnis beautiful, but when I tried washing it made no difference. Oh, Nymphs, I'm dying – and even you do nothing to save the girl who was nursed in your cave. Who will put garlands on you when I'm gone? Who will rear the poor lambs? Who will look after my chattering locust? I had a lot of trouble catching her, so that she could talk me to sleep in front of the cave – and now I can't sleep because of Daphnis, and she chatters away for nothing.'

That was how she suffered and that was how she talked, as she tried to find a name for love. But Dorcon, the cowherd who had pulled Daphnis and the he-goat out of the pit, was a youth whose beard had already begun to grow, and he knew what love was called and also what it meant. He had fallen in love with Chloe on that very day, and as other days went by his feelings

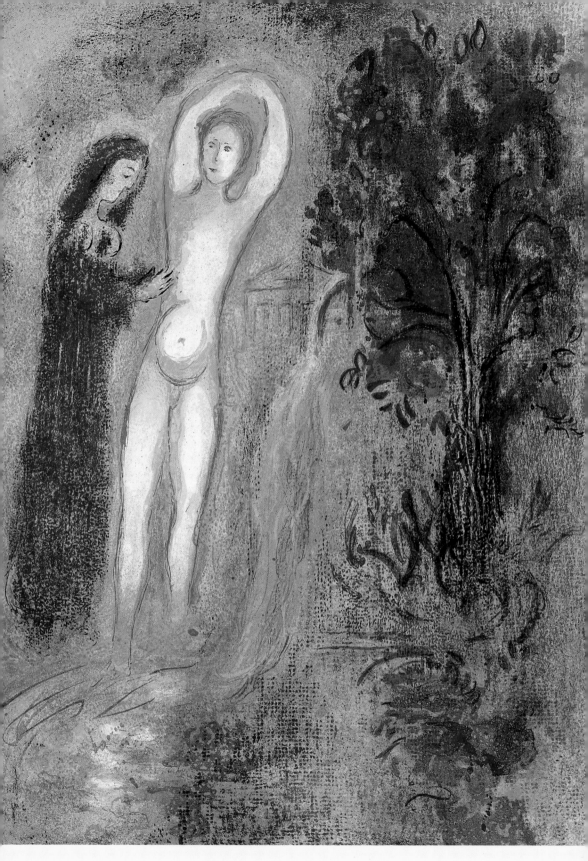

Daphnis and Chloe at the Spring

had become more and more inflamed. So regarding Daphnis as too young to be taken seriously, he decided to achieve his object either by bribery or by force.

He began by bringing them presents – for Daphnis a cowherd's Pan-pipe consisting of nine reeds fastened together with bronze instead of wax, and for Chloe a Bacchic fawnskin that looked as if the colours had been put on with paint. Then, having come to be regarded as a friend, he gradually took less and less notice of Daphnis but kept bringing Chloe presents every day – either a delicious cheese, or a garland of flowers, or some summer apples. And once he actually brought her a new-born calf, and a wooden bowl decorated with gold, and some young mountain-birds. Having had no experience of the methods employed by lovers, Chloe was only too glad to accept the presents, because she thus had something to give Daphnis.

One day – for it was now Daphnis's turn to realize what love meant – he and Dorcon engaged in a beauty-contest. Chloe was the judge, and the prize for victory was the privilege of kissing Chloe.

Dorcon spoke first, to this effect:

'Well, my girl, I'm bigger than Daphnis. And I'm a cowherd and he's a goatherd, so I'm as much superior to him as cows are to goats. Also my skin's as white as milk, and my hair's as red as corn that's just going to be reaped. And I was nursed by my mother, not by an animal. But this fellow's quite short, and he's as beardless as a woman and as dark as a wolf. And he grazes he-goats and smells awful as a result. And he's too poor even to keep a dog. And if it's true that he was suckled by a goat, as people say, he's really no better than a kid.'

When Dorcon had said something like this, Daphnis replied:

'Certainly I was suckled by a goat – so was Zeus. And the he-goats that I graze are bigger than his cows. And they don't make me smell, because even Pan doesn't smell and he's three-quar-

ters goat. And I've got plenty of cheese, and bread baked on a spit, and white wine, and all that a peasant needs to make him rich. I haven't got a beard, but neither has Dionysus. I'm dark, but so are hyacinths – and Dionysus is superior to the Satyrs, and so are hyacinths to lilies. But this fellow's as red as a fox, and he's got a beard like a he-goat, and his skin's as white as a town-lady's. And if you have to kiss someone, you can kiss my mouth, but all you can kiss of him is the hair on his chin. And remember, dear girl, that you yourself were nursed by a sheep – and even so you're beautiful.'

Chloe waited no longer but, partly because she was pleased by the compliment and partly because she had been wanting to kiss Daphnis for a long time, she jumped up and kissed him. It was an artless and inexperienced sort of kiss, but one which was quite capable of setting a heart on fire. So Dorcon ran off in dismay, and began to look for some other method of satisfying his love. But Daphnis reacted as if he had been stung rather than kissed. He suddenly looked almost indignant and shivered several times and tried to control his pounding heart; he wanted to look at Chloe, but when he did so he blushed all over. Then for the first time he saw with wonder that her hair was as golden as fire, that her eyes were as big as the eyes of an ox, and that her complexion was really even whiter than the milk of the goats. It was as if he had just got eyes for the first time, and had been blind all his life before.

So he stopped eating any food except for a mere taste, and if he had to drink he did no more than moisten his lips. Before, he had been more talkative than a locust; now he was taciturn. Before, he had been more active than a goat: now he sat idle. His flock was forgotten; even his Pan-pipe was thrown aside. His face was paler than grass at midsummer. The only person that he would talk to was Chloe; and if ever he was apart from her and alone, he would rave away to himself like this: 'Whatever is

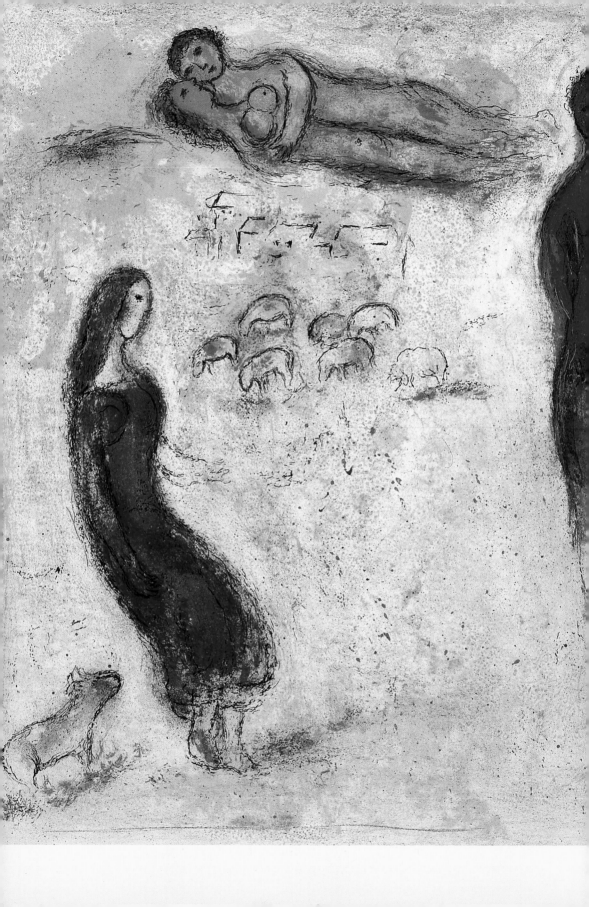

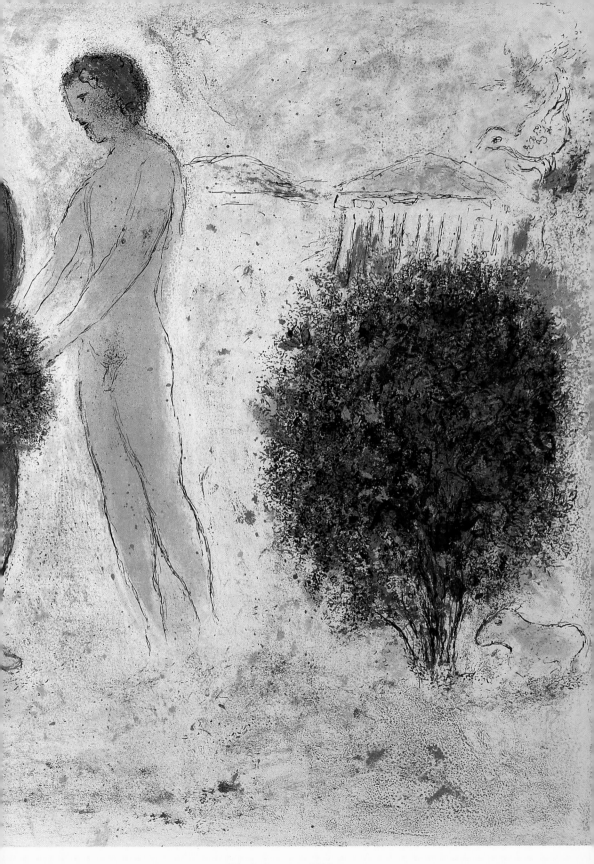

The Judgement of Chloe

Chloe's kiss doing to me? Her lips are softer than roses and her mouth is sweeter than honey, but her kiss hurts more than the sting of a bee. I've often kissed kids, and I've often kissed new-born puppies and the calf that Dorcon gave her, but this kiss is something quite new. My breath's coming in gasps, my heart's jumping up and down, my soul's melting away – but all the same I want to kiss her again. Oh, what an unlucky victory! Oh, what a strange disease – I don't even know what to call it. Had Chloe drunk poison just before she kissed me? If so, how did she manage not to be killed? Hear how the nightingales are singing – and my pipe is silent. Look how the kids are frisking about – and I'm sitting still. Look how the flowers are blooming – and I'm not making any garlands. Yes, the violets and the hyacinths are in flower, but Daphnis is withering away. Is Dorcon going to seem better-looking than I am after all?'

That was how the worthy Daphnis suffered, and that was how he talked; for it was his first experience of love, and the language of love. But Dorcon, the cowherd who was in love with Chloe, watched for a moment when Dryas was planting a tree beside a vine, and went up to him with some excellent little cheeses. These he gave Dryas as a present, for they had been friends in the old days when Dryas had done the grazing himself; and after this introduction he broached the subject of Chloe's marriage. He promised that if he could have her as his wife, he would give Dryas many splendid gifts (splendid, that is, from a cowherd's point of view): a yoke of oxen for ploughing, four hives of bees, fifty apple-trees, a bull's hide for cutting into sandals, and a weaned calf every year. Dryas was charmed by these offers and very nearly gave his consent. But thinking that the girl deserved a better husband, and fearing that he might be found out one day and get into serious trouble, he declined the match, begged to be excused, and refused the presents that Dorcon had offered.

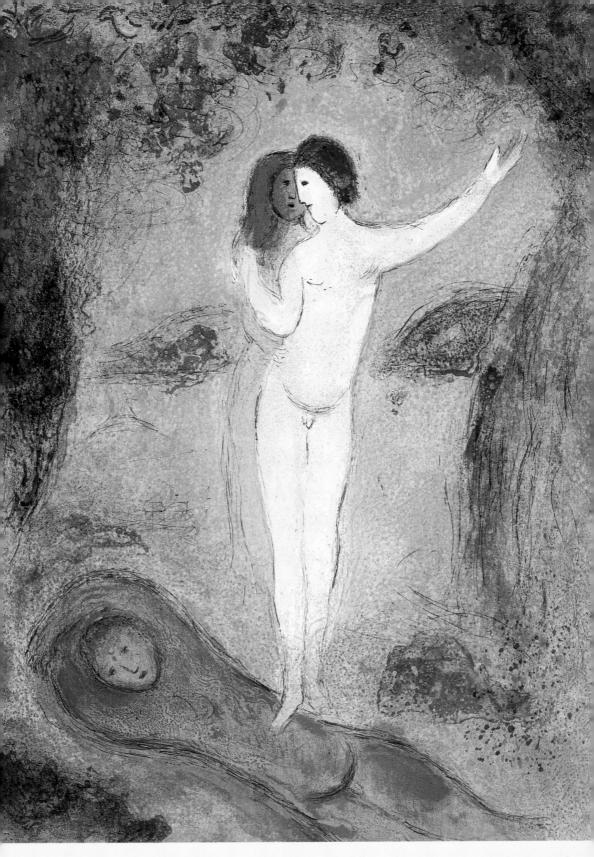

Chloe's Kiss

Thus Dorcon was disappointed for the second time and had
sacrificed his good cheeses for nothing; so he determined to lay
hands on Chloe when she was alone. Noticing that they took it in
turns to drive the flocks to water, Daphnis doing it one day and
the girl the next, he devised a stratagem of a suitably bucolic na-
ture. He took the skin of a big wolf that a bull had once gored to
death when fighting in defence of the cows, and threw it over his
shoulders so that it hung down to his feet. He then pulled it
round his body in such a way that the front paws fitted over his
hands and the back paws over his legs right down to the heels,
and the gaping mouth covered his head like a soldier's helmet.
Having done his very best to make a beast of himself, he went to
the spring at which the goats and sheep were watered after graz-
ing. The spring was in a deep hollow in the ground, and the
whole place round it grew wild with thorns and brambles and
stunted junipers and thistles. In fact a real wolf could easily have
lurked there without being seen.

Here Dorcon hid and waited for watering-time, quite confi-
dent that he would be able to frighten Chloe by his appearance
and get his hands on her.

Shortly afterwards Chloe started driving the flocks to the
spring, leaving Daphnis cutting green leaves for the kids to eat
when they had finished grazing. But the dogs that went with her
to guard the sheep and the goats – dogs are always such busy-
bodies about nosing things out – got wind of Dorcon as he was
moving forward to attack the girl. So they set up a shrill barking,
and thinking that he was a wolf they made a rush at him, sur-
rounded him before his panic had allowed him to get right up,
and started biting away at the skin. For a time he lay silent in the
undergrowth, as he felt embarrassed at the thought of being
found out, and was protected by the skin that covered him. But
when Chloe, terrified at the first sight of him, began calling to
Daphnis for help, and the dogs pulled off the skin and got at

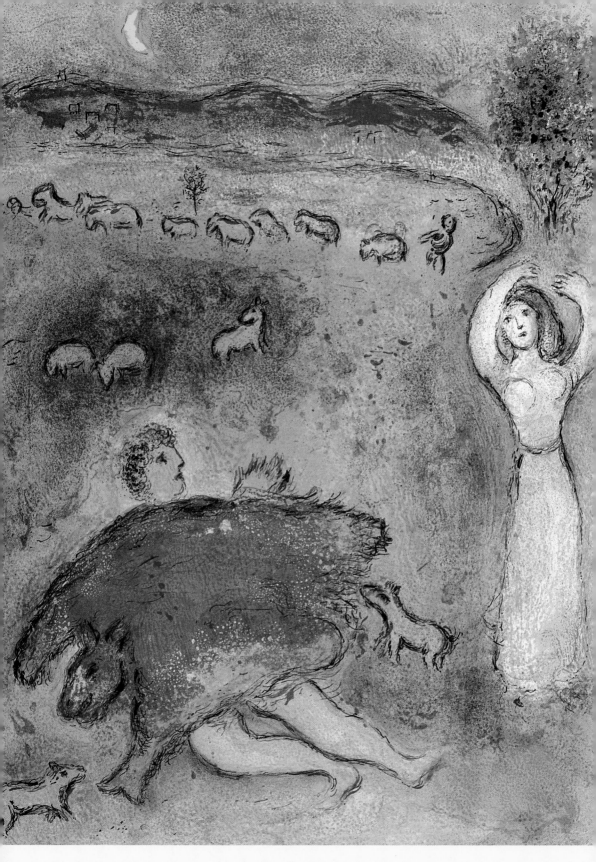

Dorcon's Stratagem

Dorcon himself, he let out a loud yell and begged the girl and Daphnis, who had now arrived, to come to the rescue. So they gave their usual call for the dogs to come back, and quickly pacified them. As for Dorcon, he had been bitten all over his thighs and shoulders, so they led him to the spring, washed the bites clean where the teeth had gone in, and after chewing up some green elm-bark applied it as a dressing.

Having had no experience of the lengths to which lovers will go, they supposed that the skin had been put on for some sort of pastoral joke. So they were not at all annoyed but were most sympathetic and walked arm in arm with him for quite a way before sending him off.

Thus Dorcon had a very narrow escape, being literally snatched from the jaws, not of the proverbial wolf, but of a dog; and he went home to tidy himself up. But Daphnis and Chloe were kept hard at work until it was dark collecting the she-goats and the ewes, for they had been scared by the skin and thrown into a panic by the barking of the dogs, so that some had run up high rocks and others had run down to the very edge of the sea. And yet they had been accustomed to obey the human voice and charmed by the Pan-pipe and come together at a clap of the hands. But on this occasion terror had made them forget everything else, and it was with great difficulty that Daphnis and Chloe tracked them down, like hares, by their footprints, and drove them into the folds.

Then, for once, they had a good night's sleep and weariness relieved the pain of love. But when day returned their feelings were again much the same as before. They were delighted to see each other again and miserable when they were parted. They wanted something, but they did not know what they wanted. All they knew was this, that a kiss had proved fatal to Daphnis, and a wash to Chloe.

What inflamed them even more was the time of year. It was

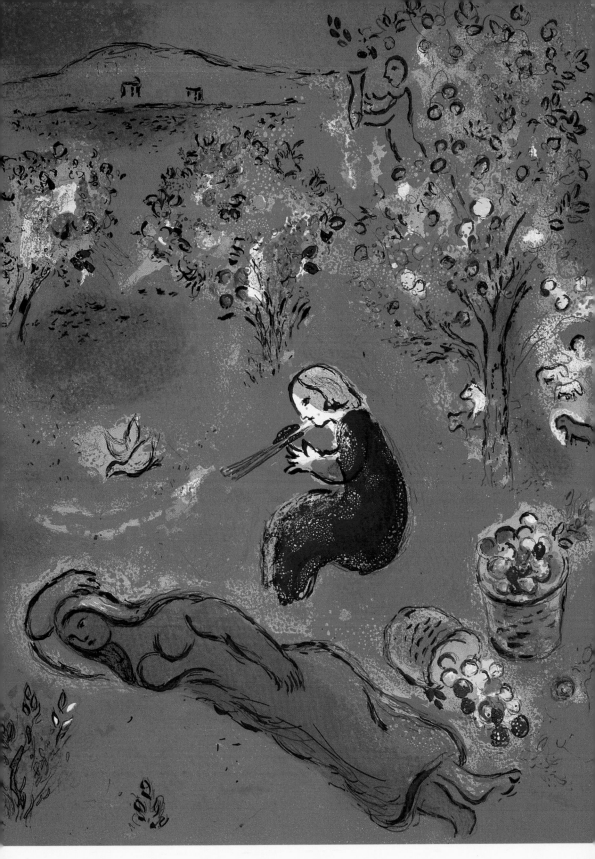

Mid-day in Summer

now the end of spring and the beginning of summer, and every-thing was at its best. There was fruit on the trees and corn in the fields; there was a pleasant sound of grasshoppers, a sweet smell of fruit, and a cheerful bleating of sheep. You would have thought that the very streams were singing as they gently flowed along, that the winds were making music as they breathed among the pines, that the apples were dropping on to the ground because they were in love, and that the sun was making everybody undress because he loved to see beauty.

So Daphnis, who was set on fire by all this, used to plunge into the streams, and sometimes he would wash himself and sometimes he would try to catch the fish that circled round him, and often he would actually drink the water in the hope of extin-guishing the fire inside him.

And Chloe, after milking the ewes and most of the she-goats, spent a good deal of time turning the milk into cheese – which was tiresome work, because the flies were a terrible nuisance and stung if you tried to drive them away. But after that she would wash her face and crown herself with pine-twigs and put on her fawnskin; and after filling her milk-pail with wine and milk she would share a drink with Daphnis.

By mid-day their eyes would have been taken prisoner. For seeing Daphnis naked, Chloe would be suddenly overpowered by all his beauty and feel faint at the impossibility of finding fault with any part of him; and Daphnis, seeing her in her fawnskin and pine-crown holding out the milk-pail, would think that he was seeing one of the Nymphs from the cave. So he would snatch the pine-crown from her head and after kissing it would put it on himself; and while he was washing and was un-dressed, Chloe would put on his clothes – and she too would kiss them first. And once they pelted each other with apples and then tidied and parted the hair on each other's heads; and she said that his hair was like myrtle-berries because it was so black,

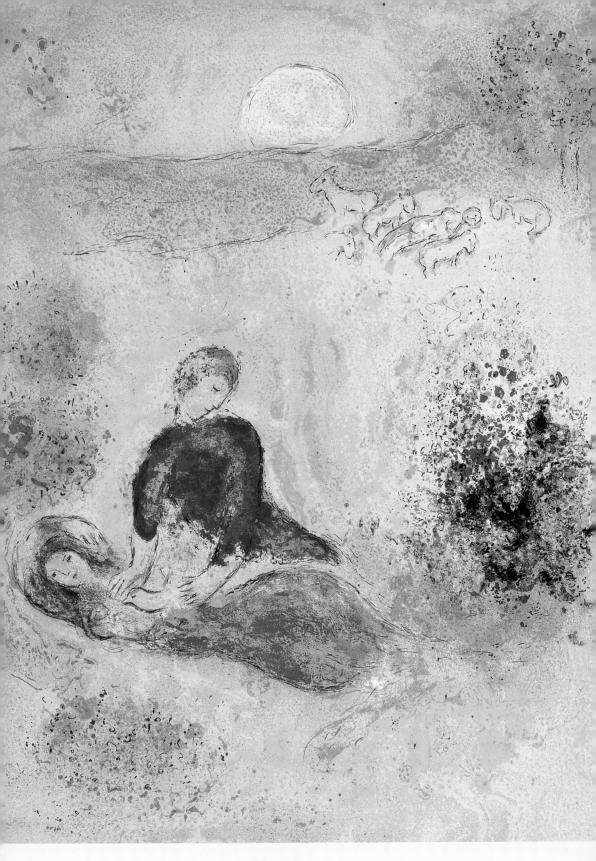

The Swallow

and he said that her face was like an apple because it was so pink and white. Also he used to give her lessons in playing the Pan-pipe, and the moment she had begun to blow into it he would snatch it away and run his own lips over the reeds. This was supposed to show her where she had gone wrong, but actually it was a good excuse to kiss Chloe *via* the pipe.

Once when he was playing his pipe in the middle of the day and the flocks were lying in the shade, Chloe fell asleep without realizing it. Noticing this, Daphnis put down his pipe and now that he had no reason to feel shy he began to gaze insatiably at every part of her, and at the same time to speak in a cautious undertone: 'What eyes are sleeping there! What a mouth – its breath is sweeter than the scent of apples or pears! But I daren't kiss her, because kisses sting one's heart and drive one mad, just like new honey. And if I kiss her I'm afraid I may wake her up. Oh, those chattering grasshoppers! They'll never let her sleep if they make so much noise. And now the he-goats are fighting too, and crashing their horns together! Oh, you wolves must be more cowardly than foxes, or you'd have carried them off by now!'

While he was talking like this, a grasshopper trying to escape from a swallow that wanted to capture it landed in Chloe's bosom. The swallow, closely pursuing, failed to catch the grasshopper but in its efforts to do so it came quite near to Chloe and touched her cheek with its wings. Not knowing what had happened, she gave a loud scream and woke up with a start; but when she saw the swallow still flying near her, and Daphnis laughing at her fears, she stopped being frightened and started rubbing her eyes, which wanted to go on sleeping. Then the grasshopper let out a chirp from her bosom, as if it had gone there for sanctuary and was thanking her for saving its life. So Chloe gave another loud scream. But Daphnis laughed and, taking advantage of the situation, put his hands down between her breasts and drew out that excellent grasshopper, which never

stopped chirping even when it was in his right hand. Chloe was delighted to see it. She kissed it and picked it up and put it back, still chattering, in her bosom.

One day a wood-pigeon entertained them by singing a pastoral song from the wood. And when Chloe wanted to know what it was saying, Daphnis told her, repeating a story that was on everybody's lips: 'Once upon a time, dear girl, there was a beautiful girl who used to graze a great many cows in a wood. Now she was also very musical, and in her day cows enjoyed music. So she was able to control them without either hitting them with a staff or pricking them with a goad. She would simply sit down under a pine, and after crowning herself with pine-twigs would sing the story of Pan and the Pine, and the cows would stay close enough to hear her voice. A boy who grazed cows not far away, and who was also good-looking and musical, challenged her to a singing-contest. Because of his sex, he was able to produce more volume than she could, and yet because he was only a boy, his voice had a very sweet tone. So he charmed away her eight best cows and enticed them into his own herd. The girl was annoyed at the damage done to her herd, and at being beaten at singing, and she prayed to the gods to turn her into a bird before she arrived home. The gods granted her prayer and turned her into this mountain-bird, which is as musical as she was. And even now she still goes on singing, telling her sad story, and saying that she's looking for her missing cows.'

Such were the pleasures that the summer brought them. But at the end of autumn, when the grapes were ripe, some Tyrian pirates using a small Carian vessel so as not to look like foreigners put in to those fields, and disembarking with cutlasses and breastplates started carrying off everything they could lay their hands on – some wine with a fine bouquet, immense quantities of wheat, and some honey in the honeycomb. They also drove off some cows from Dorcon's herd.

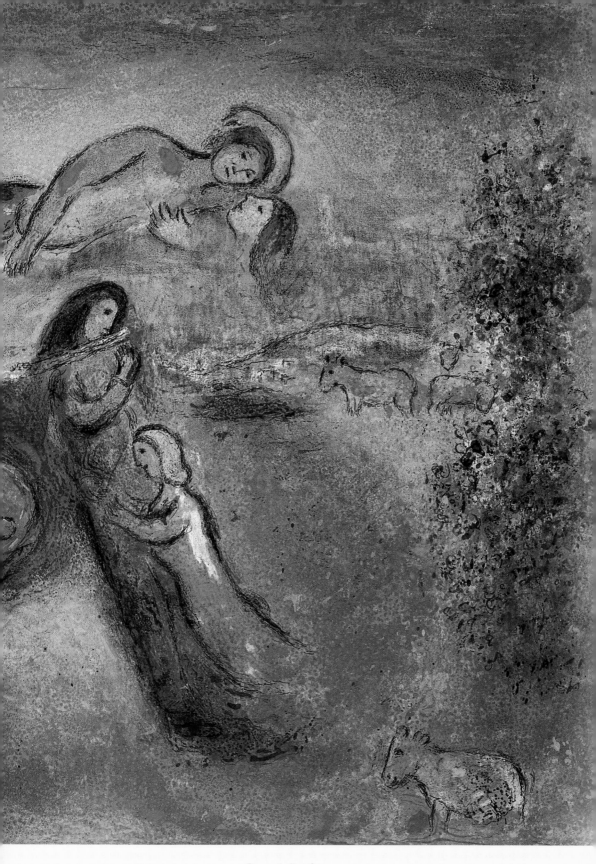

Dorcon's Death

They caught Daphnis as he was wandering about by the sea – for Chloe, being a girl, did not drive out Dryas's sheep until later, for fear of being laughed at by the other shepherds. Seeing a tall handsome youngster who was obviously worth more than plunder from the fields, the pirates wasted no more energy on the goats or on the other fields, but dragged him, weeping with desperation and loudly shouting 'Chloe!', on board their boat. Then they immediately untied the mooring rope, put their oars into the water, and started out to sea.

Chloe, meanwhile, was driving out her flock, bringing with her a new Pan-pipe as a present for Daphnis, but when she saw the goats all scattered, she forgot about the sheep, threw down the pipe, and ran off to ask Dorcon for help. Dorcon, however, was lying almost hacked to pieces by savage cuts from the pirates, scarcely able to breathe and streaming with blood. But when he saw Chloe a tiny spark of his former love revived.

'Chloe,' he said, 'I'll be dead in a moment, for when I tried to defend my cattle those devilish pirates carved me up as if I'd been an ox myself. But you must save your Daphnis and avenge me and destroy them. I've trained the cows to follow the sound of a Pan-pipe and to go wherever they hear it playing, even if they're grazing somewhere a long way off. So quick, take this pipe and play the tune on it that I once taught Daphnis, and Daphnis taught you. After that it'll be up to the pipe and the cows out there. And you can have the pipe itself as a present – I've won a lot of contests with it against cowherds and goatherds too. And in return, please kiss me while I'm still alive, and weep for me when I'm dead, and if you see someone else grazing my cows, remember me.'

Having said this Dorcon kissed his last kiss, and with that kiss and with those words he died. But Chloe picked up the pipe and put it to her lips and blew on it as loudly as she could. The cows heard and recognized the tune, gave an answering moo, and

leapt with one accord into the sea. What with this violent jumping against one side of the boat, and the fact that the falling cows made a deep trough in the sea, the boat capsized and, as the waves came together again, it sank. Its occupants went overboard with very unequal chances of survival, for the pirates were equipped with cutlasses and wore scale-armoured breastplates and greaves reaching half-way up their shins, but Daphnis had nothing on his feet, as he was dressed for grazing on a plain, and was half-naked as the weather was still scorching hot. So before they would swim far the pirates were carried down to the bottom by the weight of their equipment, whereas Daphnis got out of his clothes quite easily, although he still found it difficult to swim as he had only swum in rivers before. Necessity, however, soon taught him what to do, and he plunged into the middle of the cows and seizing the horns of two of them in his two hands was carried along between them, without any trouble or effort, as though he was driving a cart. Cows, you see, swim even better than human beings: the only things to beat them are water-fowl and actual fishes. A swimming cow will never come to grief unless its hoofs become sodden and drop off. This is confirmed by the fact that many parts of the sea are called Bospori, or Cattle-crossings, to this day.

In this way Daphnis was most unexpectedly saved from two sorts of danger, piracy and shipwreck. When he got to land and found Chloe laughing and crying at the same time, he rushed into her arms and asked what had been the idea of playing the pipe. So she told him the whole story, how she had run off to find Dorcon, how the cows had been trained, how she had been instructed to play the pipe, and how Dorcon was dead. The only thing she did not like to mention was the kiss.

It seemed only right to pay their respects to their benefactor, so they went off with his relations to poor Dorcon's funeral. They piled a great deal of earth on his grave and planted a great

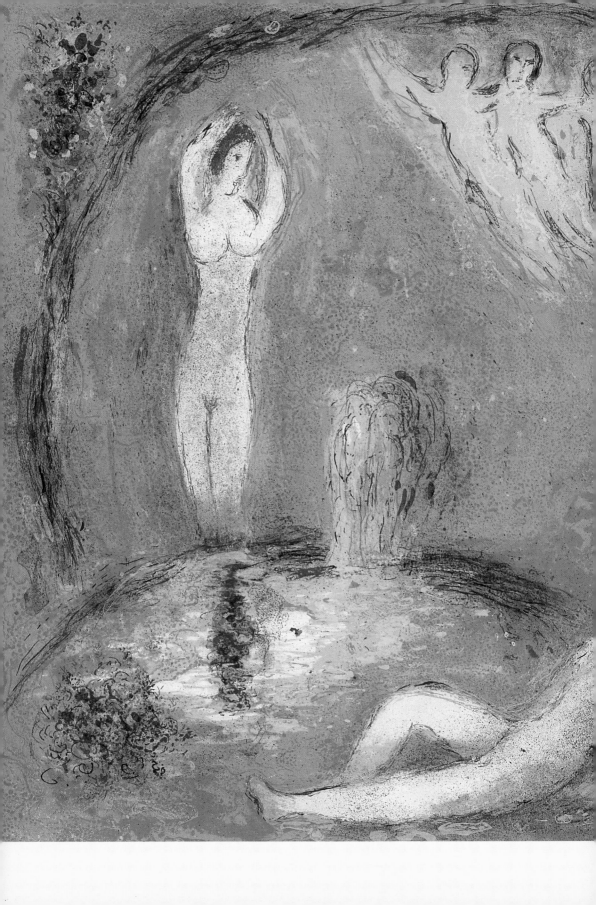

Daphnis and Chloe in the Nymphs' Cave

many garden trees and hung up the first-fruits of their labours in his honour. Besides this, they poured some libations of milk, and squeezed out the juice of some grapes, and broke several Pan-pipes. Some pitiful moos were also heard from the cows, and as they mooed they were seen running wildly about. And this – or so the shepherds and goatherds imagine – was the cows' way of mourning for their departed herdsman.

When Dorcon's funeral was over, Chloe took Daphnis to the Nymphs in the cave and washed him. And then for the first time she let Daphnis see her washing her own body, which beauty had already made white and clean and which needed no washing to make it beautiful. Then after gathering some flowers, all the flowers that were to be found at that time of year, they put garlands on the statues and hung Dorcon's pipe on the rock as a thank-offering.

After that they went to see how the goats and the sheep were getting on. They were all lying down, not grazing or bleating but feeling sad, I think, because Daphnis and Chloe were nowhere to be seen. At any rate as soon as they appeared and gave their usual call and played their pipes, the sheep got up and started to graze and the goats began snorting and frisking about as though they were delighted at the safe return of their usual herdsman.

But Daphnis could not bring himself to feel cheerful now that he had seen Chloe naked and seen beauty revealed which had previously been hidden. He had a pain in his heart as though it was being eaten away by poison. His very breathing was affected; sometimes he panted violently as if someone were chasing him, and sometimes he could hardly breathe at all, as if all his breath had been used up in the recent attack. That wash seemed to him more terrible than the sea. He felt as though his life was still at the mercy of the pirates; for he was young and lived in the country and as yet knew nothing of the piracy of Love.

Second Book

As the fruit-season was now at its height and the vintage was close at hand, everyone was at work in the fields. Some were getting wine-presses ready, some were cleaning out wine-jars, and some were weaving baskets. One man was busy with a small reaping-hook for cutting bunches of grapes, another with a stone for squeezing the juice out of the bunches, and another with a dry willow-shoot that had been pounded into shreds to provide torchlight by which the must could be drawn off during the night. So Daphnis and Chloe paid less attention to their goats and sheep and gave a helping hand to various people in various ways. Daphnis carried bunches of grapes in baskets, and threw them into the wine-presses, and trod them down, and drew off the wine into jars; and Chloe prepared food for the fruitpickers, and poured out drinks of old wine for them, and picked the grapes off the shorter vines. For in Lesbos all the vines are fairly short, instead of being tall and growing up trees. The shoots spread out quite low down and creep along the ground like ivy. In fact a baby that had only just got its hands out of its swaddling-clothes could easily help itself to a bunch of grapes.

As was only to be expected at a festival held in honour of Dionysus and the birth of wine, the women who had been called in from the neighbouring fields to help with the vintage started making eyes at Daphnis and praising his beauty and saying that he was just like Dionysus. And one of the bolder ones actually kissed him – which excited him and annoyed Chloe.

Similarly the men in the wine-presses shouted all kinds of remarks at Chloe, and jumped madly up and down like Satyrs before some Bacchante, and prayed that they might be turned into sheep and have her as their shepherdess. So this time Chloe was

pleased and Daphnis annoyed. And now they both began to pray that the vintage might soon be over, so that they could get back to their usual surroundings and instead of discordant shouts hear the music of the Pan-pipe and the bleating of their flocks.

So when, a few days later, the vines had been stripped, and the must had been poured into jars, and there was no longer any need for extra hands, Daphnis and Chloe drove their flocks down on to the plain. There they joyfully did homage to the Nymphs and offered them some bunches of grapes on vine-shoots as the first-fruits of the vintage. Not that they had ever neglected the Nymphs in the past; on the contrary they always visited them at the beginning of each day's pasturing, and always did them homage on their way back from the pasture. Nor had they ever failed to bring them some offering – either a flower or some fruit or some green leaves or a libation of milk. And for this they had their reward from the Goddesses later on. But that day they were like dogs let off the leash, as the saying is – dancing about and playing the pipe and singing and wrestling with the he-goats and the rams.

While they were amusing themselves like this, an old man came up to them. He was dressed in a patchwork of skins, had raw-hide sandals on his feet and a knapsack slung from his shoulders – a knapsack as ancient as himself. He sat down beside them and spoke as follows:

'I'm old Philetas, my children. Many's the song I've sung to these Nymphs here, and many's the tune I've piped to Pan over there, and many's the herd of cows I've led by music alone. And I've come to tell you what I've seen and repeat to you what I've heard. I have a garden that I made with my own hands. I've been working on it ever since I gave up being a herdsman because of my age, and every season it supplies me with all the produce of that season. In spring there are roses, lilies, hyacinths and both

46

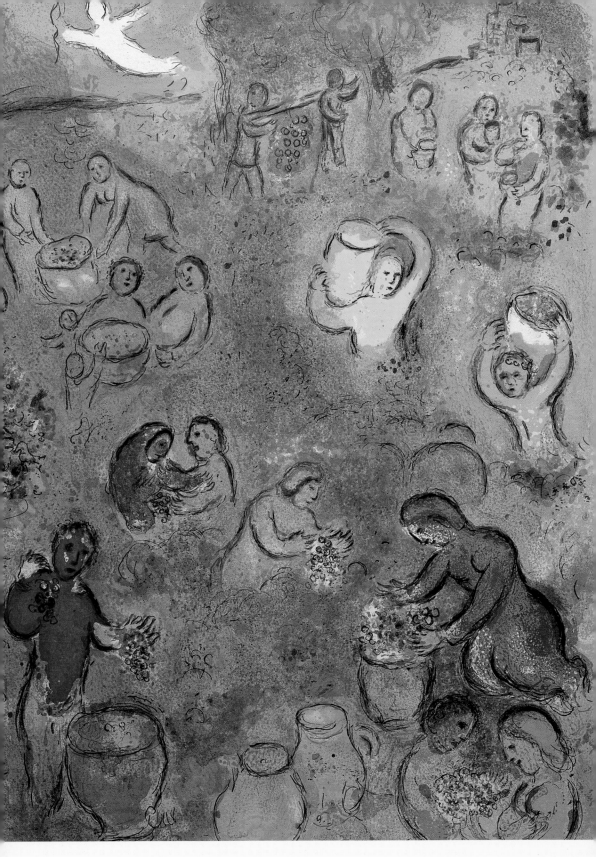

The Vintage

kinds of violet, in summer there are poppies and pears and all sorts of apples, and now there are grapes and figs and pomegranates and the fruit of the green myrtle. Flocks of birds collect in this garden of mine every morning, some looking for food and some just wanting to sing – for it's overhung with trees and full of shade and watered by three springs. In fact, if you took away the fence, my garden would look exactly like a small wood.

'When I went there today about mid-day, I saw, under the pomegranate-trees and the myrtles, a boy with myrtle-berries and pomegranates in his hands. His skin was as white as milk, and his hair was as golden as fire, and his body glistened as if he'd just been bathing. He was naked, he was all alone, and he was playing and picking fruit as if the garden belonged to him. So I made a rush at him to catch him, for I was afraid he'd damage the myrtles and the pomegranate-trees with his naughty behaviour. But he kept dodging lightly and easily away, sometimes running under the rose-bushes and sometimes hiding under the poppies, like a young partridge. Well, I've often had a lot of trouble chasing unweaned kids, and I've often worn myself out running after new-born calves – but this was a cunning little thing and just couldn't be caught.

'Being an old man, I soon got tired. So leaning on my stick and watching to see he didn't escape, I asked which of the neighbours was his father, and what he meant by picking fruit in someone else's garden. He made no reply, but came and stood near me and started laughing very softly and pelting me with the myrtle-berries. Somehow, I don't know how, he charmed away my anger. So I asked him not to be frightened any more but to come into my arms, and swore I'd let him go, and give him some apples and pomegranates as well, and allow him to pull the fruit off my trees and pick my flowers whenever he liked – if he'd give me just one kiss.

'At that he laughed very loudly and produced a voice sweeter than any nightingale's, or any swallow's, or any swan's – even if the swan were as old as I am.

'"As far as I'm concerned, Philetas," he said, "I've no objection to kissing you, for I want to be kissed even more than you want to be young again. But think – would it be a suitable thing to give you at your time of life? For your age won't save you from running after me when you've had your one kiss. And you'd find me very hard to catch, even if you were a hawk or an eagle or a bird that flew faster than them. For I'm not really a boy, even if I look like a boy. I'm older than Time and the universe itself. And I've known you ever since your earliest youth, when you used to graze a huge herd of cows in that water-meadow, and I used to sit beside you while you played your Pan-pipe underneath those oaks, when you were in love with Amaryllis. But you didn't see me, even when I was standing quite close to the girl. Well, I gave her to you, and by this time you have some fine sons who are cowherds and farmers. But now it's Daphnis and Chloe that I'm looking after. And when I've brought them together in the morning, I come into your garden to enjoy the flowers and the trees, and also to bathe in these springs. That's why the flowers and the trees are so beautiful – because they get splashed with water when I'm bathing. And now see for yourself whether any of your trees have been broken down, or any of your fruit has been picked, or any of your flowers have had their stalks trodden on, or any of your springs have been muddied. And you can count yourself lucky, for you're the only man in the world who, in his old age, has seen this boy."

'Having said this, he hopped like a young nightingale on to the myrtles, and making his way from branch to branch climbed up to the top. I had a glimpse of wings growing out of his shoulders and a tiny bow slung between his shoulders and his wings. The next moment I couldn't see either the bow or him. But un-

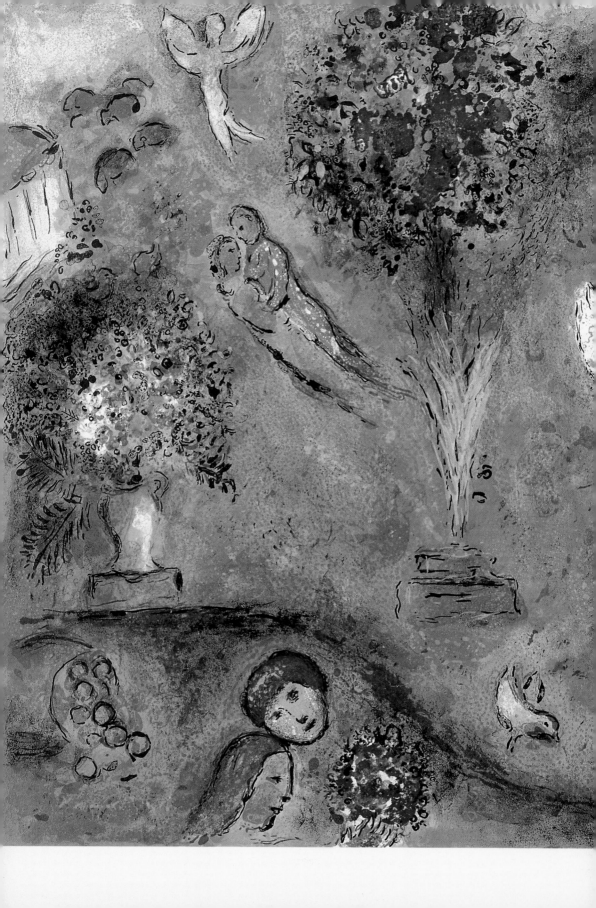

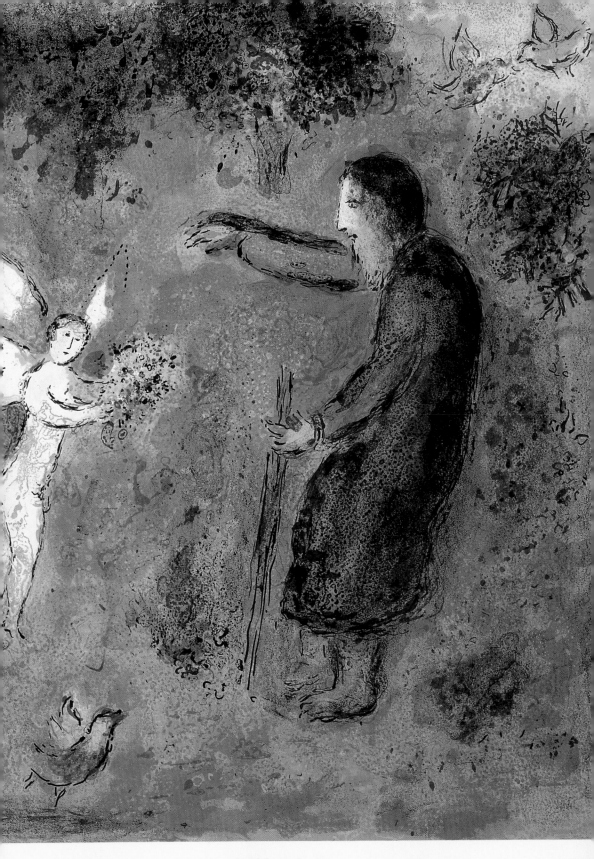

In Philetas's Garden

less I've grown these white hairs for nothing and am getting weak-minded in my old age, you, my children, are dedicated to Love, and Love is looking after you.'

Daphnis and Chloe were much amused, as though they had been listening to fiction rather than fact, and asked:

'But whatever *is* Love – a boy or a bird? And what can he do?'

So Philetas went on to say:

'Love, my children, is a god, young and beautiful and winged. That's why he delights in youth and pursues beauty and gives wings to the soul. And he can do greater things than Zeus himself. He has power over the elements, he has power over the stars, he has power over his fellow-gods – far more than you have over your goats and your sheep. The flowers are all Love's handiwork. These trees are his creations. He is the reason why rivers run and winds blow. I've even known a bull that fell in love, and used to bellow as if he'd been stung by a gadfly. And I've known a he-goat that loved a she-goat and followed her everywhere.

'Why, I myself was young once and fell in love with Amaryllis. And I forgot to eat, and I never had anything to drink, and I got no sleep. My soul ached, my heart throbbed, my body was icy-cold. I used to cry out as though I was being beaten, and fall silent as though I was being turned into a corpse, and plunge into rivers as though I was on fire. I used to call on Pan for help, since he himself had been in love with the Pine. I used to praise Echo for repeating Amaryllis's name after me. I broke my Pan-pipes, because although they charmed my cows they didn't bring Amaryllis to me. For there's no medicine for Love, nothing you can drink and nothing you can eat and no magic spell that you can say. The only remedies are kissing and embracing and lying down together with naked bodies.'

Having given them these instructions Philetas went away, after accepting some cheeses from them and a kid that had al-

ready got its horns. As soon as they were left alone, their minds were gripped by a sort of madness, for it was the first time that they had heard the name of Love; and when they returned to their cottages that night, they started comparing their own experiences with what they had just heard:

'People who are in love feel pain, and so do we. They lose interest in the things we've lost interest in. They can't sleep, and that's our trouble at this very moment. They feel as if they were on fire, and there's a fire inside us too. They long to see each other, and that's why we pray for the day to come more quickly. It must be love. And we must be in love with each other without realizing that it's love and that we're loved. Why, then, do we feel this pain? And why are we always looking for each other? Because everything that Philetas said was true. The boy in the garden was also seen by our fathers in that dream, and he ordered us to graze flocks. How can one possibly catch him? He's tiny and will get away. And how can one get away from him? He's got wings and will overtake one. We must run and ask the Nymphs to help us. But Pan didn't help Philetas when he was in love with Amaryllis. Then we'll have to try the remedies he spoke of, kissing and embracing and lying naked on the ground. It'll be very cold, but Philetas put up with it and so will we.'

Thus their education was continued during the night; and next day, when they drove their flocks to pasture, they kissed as soon as they met, a thing they had never done before, and locked their arms together in an embrace. But they hesitated to try the third remedy, undressing and lying down, since this called for more assurance than you would expect to find in a girl, or even in a young goatherd. So they had another sleepless night, thinking over what they had done and blaming themselves for what they had left undone.

'We tried kissing,' they thought, 'and it was no use. We tried embracing, and got nothing out of it. Apparently the only cure

for love is lying down together. We must try that too. There must be something in it that will be more effective than kissing.'

After such thoughts as these they naturally had dreams about love, about their kisses and their embraces; and what they had failed to do during the day, they did in their dreams – they lay with each other naked. So they got up next morning possessed by an even greater longing, and feeling impatient for kisses started whistling their flocks down to the pasture. And as soon as they saw one another they ran together smiling.

Well, the kissing took place and the embracing went with it; but they were rather slow about trying the third remedy, since Daphnis did not dare to suggest it and Chloe did not like to take the initiative – until, quite by accident, they tried that too.

They were sitting side by side against the trunk of an oak, and having once tasted the delights of kissing were indulging in that pleasure insatiably. They were also embracing, in order to press their lips more closely together. In the course of these embraces Daphnis pulled Chloe rather violently towards him with the result that she somehow fell over on her side, and he, following his kiss, fell over with her. Realizing that it was just like their dreams, they lay there for a long time as if they had been tied together. But as they had no idea what to do next and thought that love could go no further, nothing came of it, and after wasting most of the day they had to part, and began to drive their flocks home, cursing Night. However, they might perhaps have discovered the real thing, but for a series of events which upset the whole district.

Some rich young men from Methymna decided to celebrate the vintage by taking a holiday away from home. So they launched a small yacht, put their domestic servants at the oars, and started cruising along the Mytilenean seaboard, since that coast has plenty of harbours and is well supplied with houses. It also contains a series of bathing-pools, gardens, and woods,

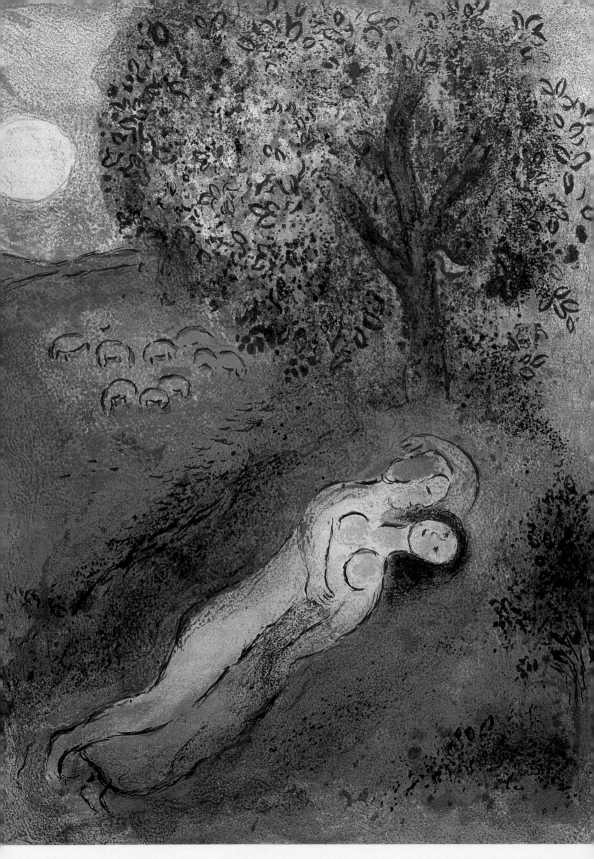

Philetas's Lesson in Love

some natural and some artificial. Altogether, it is a fine place to be young in.

They coasted along, mooring from time to time and amusing themselves with various harmless sports. Sometimes they angled for rock-fish among the rocks on the shore, using hooks suspended by fine lines from fishing-rods; and sometimes with the help of hounds and nets they caught hares that were running away from the hubbub in the vineyards. After that they gave their attention to feathered game as well, and snared wild-geese, ducks, and bustards. Thus their sport served the extra purpose of supplying their table, and if they needed anything else they used to buy it from the peasants for several obols more than it was worth. And all they ever needed was bread, wine, and shelter – for now that it was late autumn, it seemed unwise to sleep afloat and so they used to beach the yacht every night for fear of storms.

Now one of the peasants needed a rope to haul up the stone that was used for crushing the grapes after they had been trodden down, as his old rope had broken. So he stole down to the sea, approached the unguarded yacht, untied the mooring-cable, took it home and used it for his own purposes. Next morning the young men from Methymna made a search for the cable, but as no one admitted the theft they said a few hard things about their hosts and sailed further on. After coasting along for about three miles they put in to shore near the fields in which Daphnis and Chloe lived, since the plain looked a splendid place for hunting hares. Well, they had no rope to moor with, but they twisted a long green withy into a sort of rope and with this they secured the stern of the yacht to the land. Then they let the hounds loose to smell out the game, and started laying nets in likely-looking pathways.

The hounds ran about barking and terrified the goats, and the goats left the high ground and made a rush towards the sea.

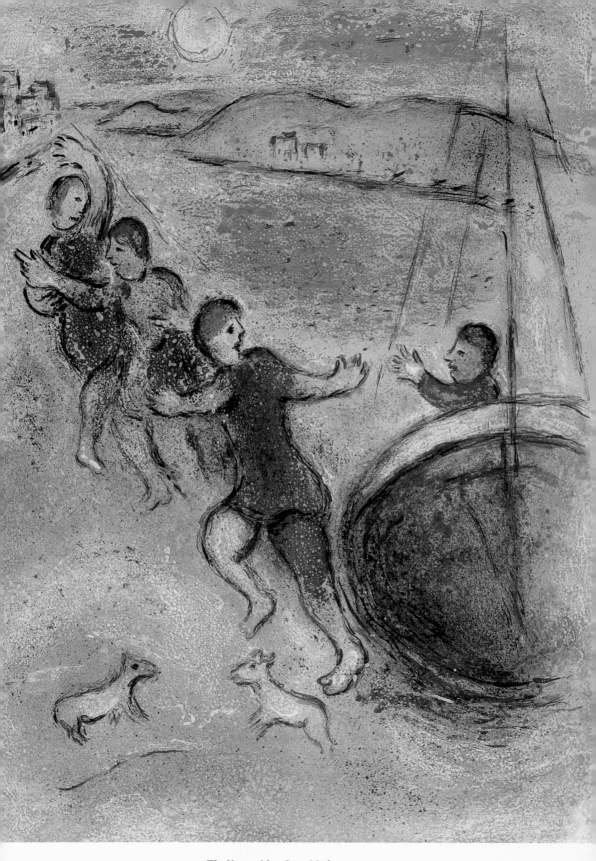

The Young Men from Methymna

Finding nothing to eat on the sand, the bolder ones approached the yacht and ate up the green withy that the yacht was moored with.

There was quite a swell on the sea, as the wind was blowing off the mountains. So the yacht was very quickly set adrift, and the backwash of the waves lifted it up and carried it out to sea.

When the Methymneans realized what had happened, some went running down to the sea and others started calling in the hounds and they all began shouting – so that all the people in the neighbouring fields heard them and came crowding together. But it was no use, for the wind was blowing its hardest and the yacht was being rapidly swept away by the irresistible force of the current.

Having thus lost a considerable amount of property, they looked for the man in charge of the goats and, when they found Daphnis, started knocking him about and tearing off his clothes. One of them actually picked up a dog-leash and tried to pull Daphnis's hands behind his back in order to tie them.

While he was being knocked about, Daphnis was shouting to the peasants for help and begging Lamon and Dryas in particular to come to the rescue; so they started fighting back – for they were tough old men and farm-work had given them brawny fists – and demanded a legal inquiry into the facts of the case.

As the others made the same demand, they appointed Philetas the cowherd to be judge, since he was the oldest man present and had a reputation among the villagers for being extremely fair.

First of all the Methymneans stated the case for the prosecution, using clear and concise language in view of the fact that they had a cowherd for a judge:

'We came to these fields because we wanted to do some hunting. We moored our yacht with a green withy and left it on the beach while we ourselves used the hounds to search for game.

Meanwhile this man's goats came down to the shore, ate up the withy and set the boat adrift. You saw her being carried out to sea, but you've no idea how many valuable things she's got in her – how much clothing has been lost – how much equipment for the hounds – how much money! Why, a man who owned as much as that could easily buy up all these fields. So in return for what we've lost, we claim the right to take this man away with us. He must be a rotten goatherd or he wouldn't graze his billy-goats among the billows!'

Such was the Methymneans' case for the prosecution. As for Daphnis, he had been knocked about so much that he was in a very bad way; but when he saw Chloe there, he forgot about everything else and spoke as follows:

'I'm an extremely good goatherd. No one in the village has ever accused any of my goats of eating up anybody's garden or breaking a budding vine. But these fellows are rotten masters of hounds and their hounds are very badly trained. Why, they behaved like a pack of wolves – ran about all over the place barking noisily and chased the goats down from the mountains and plains to the sea. They say my goats ate up the withy. Of course they did – there was no grass or wild strawberry or thyme for them on the sand. They say the yacht's been lost because of the wind and the sea. Well, that's the fault of the weather, not of my goats. They say there were clothes and money on board. But what man in his senses will believe that a boat with such a valuable cargo had a withy for a mooring-cable?'

Having said this Daphnis burst into tears and made the villagers feel extremely sorry for him. So Philetas the judge swore an oath by Pan and the Nymphs that not only Daphnis but his goats as well were wholly innocent: the guilty parties were the sea and the wind, which came under the jurisdiction of another court.

The Methymneans were not satisfied with this verdict. They

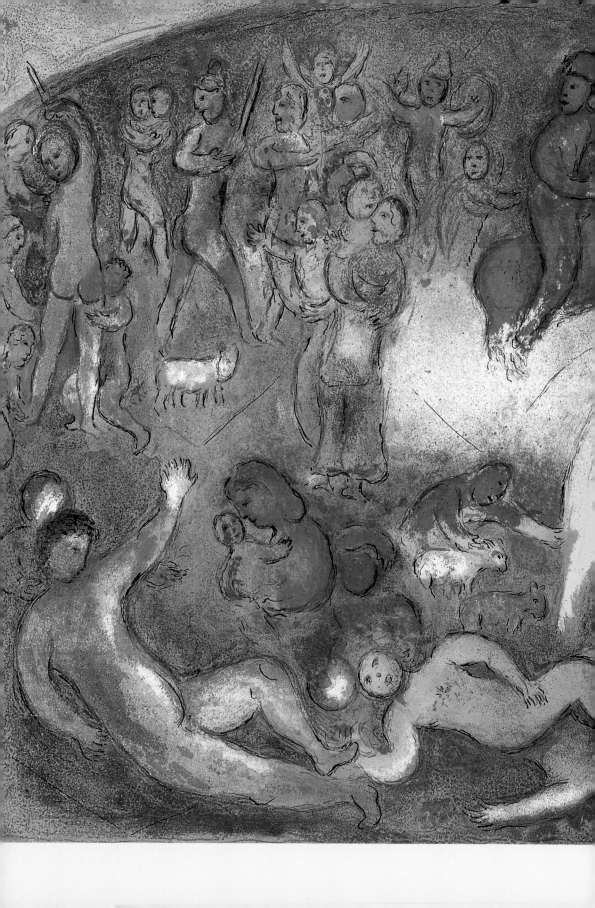

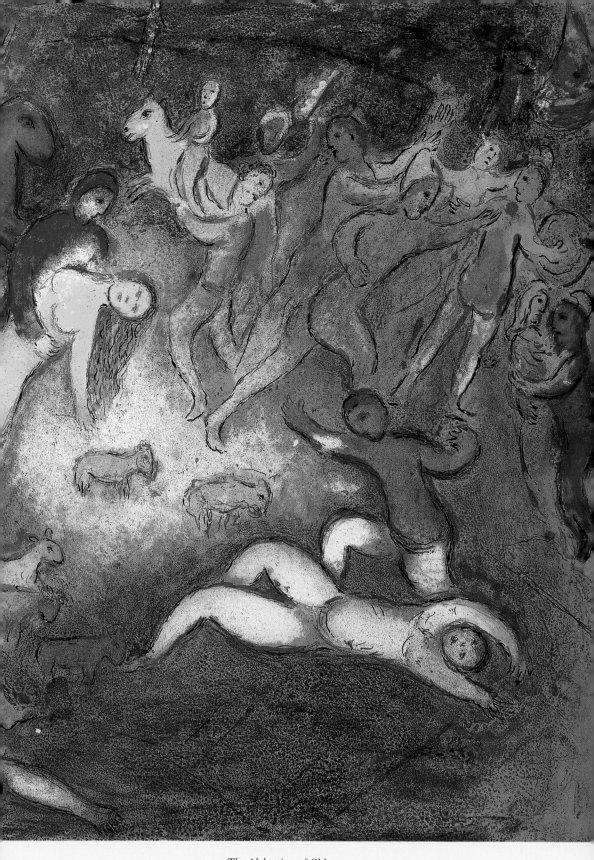

The Abduction of Chloe

made an angry rush and again started dragging Daphnis away and trying to tie him up. At this the villagers lost their tempers and swooped down on the Methymneans like a flock of starlings or jackdaws. They soon rescued Daphnis, who was now fighting in his own defence, and equally soon put their opponents to flight by hitting them with sticks; nor did they stop until they had driven them beyond the boundaries of the estate.

While the others were chasing them, Chloe was very peacefully leading Daphnis to the cave of the Nymphs. There she washed his face, which was covered with blood because a fist had smashed into his nose, and produced from her knapsack a piece of bread and a slice of cheese for him to eat. But what revived him most of all was the kiss that she gave him with her soft lips – a kiss that was like honey.

So on that occasion Daphnis had a very narrow escape; and they had not yet heard the last of the affair, for when the Methymneans finally got home, after being transformed from yachtsmen into pedestrians, from luxurious holiday-makers into wounded warriors, they called an assembly of the citizens, took olive-branches in their hands as a symbol of supplication, and begged to be granted vengeance. They did not say a word about what had actually happened for fear of making themselves ridiculous on top of everything else, considering how they had been treated by a lot of shepherds. Instead, they accused the Mytileneans of having confiscated their yacht and robbed them of their property by force of arms.

Because of their wounds, their story was believed; and the citizens thought it only right to avenge the young men, since they belonged to the leading families in the town. So they voted for an undeclared war on the Mytileneans and instructed their general to launch ten ships and ravage the enemy's seaboard; for as winter was approaching they could not with any safety send a larger fleet to sea.

The very next day the general put out to sea with soldiers at the oars, and invaded the coastal districts of Mytilene. They carried off a great many sheep, a great deal of corn and wine – for the vintage was only just over – and several people who were working in the fields. They also raided the fields where Daphnis and Chloe lived, and after making a surprise landing began to seize everything they could lay their hands on.

Daphnis was not grazing his goats at the time, but had climbed up into the wood and was cutting green leaves so as to have food to give the kids during the winter. Consequently he saw the raid going on below, and hid in the trunk of a dry beech.

Chloe, however, was with the flocks, and when she saw men coming after her she ran for sanctuary to the Nymphs and in the name of those goddesses begged her pursuers to spare both her animals and herself. But it was no use, for the Methymneans jeered contemptuously at the images and not only carried off the animals but actually drove her along with them, treating her exactly like the sheep and goats and lashing her with switches of willow.

Now that they had filled their ships with plunder of every kind, they decided not to sail any further but set course for home, feeling nervous, of both the weather and the enemy. So off they sailed, having to work extra hard at the oars because there was no wind.

When everything was quiet, Daphnis came down to the plain where they used to graze their flocks. But the goats were nowhere to be seen, the sheep had disappeared, and instead of Chloe all he found was a great solitude, and her Pan-pipe thrown away at the spot where she used to play with it. He gave a loud cry and ran off wailing piteously first to the oak where they usually sat, then to the sea, in case there was any sign of her there, then to the cave of the Nymphs, where she had gone for sanctuary when the Methymneans were trying to drag her away.

There he threw himself down on the ground and began to reproach the Nymphs for having betrayed him.

'Was Chloe carried off under your very eyes?' he asked. 'And could you bear to see it? The girl that's been making garlands for you and offering you the firstlings of the milk – the girl that hung up this very Pan-pipe here? No wolf has ever robbed me of a single goat and now enemies have gone off with the whole herd and the girl that helped me graze them! The goats will be flayed and the sheep will be sacrificed and Chloe – from now on will live in a town. How can I bring myself to face my father and mother, without the goats, without Chloe? They'll say that I've deserted my post. Why, I haven't even got anything left to graze – so I'll go on lying here until I die or until there's another war. Oh, Chloe, are you feeling as miserable as I am, when you remember this plain, and the Nymphs here, and me? Or do you find the sheep some comfort – and the goats that have been taken prisoner with you?

While he was talking like this, a deep sleep came and took him out of his tears and grief. He dreamed he saw the three Nymphs, tall and beautiful women just like their images, half-naked and barefooted, with their hair falling free. First of all they seemed to be sympathizing with Daphnis, and then to cheer him up the eldest spoke as follows:

'Don't reproach us, Daphnis, for we're even more concerned about Chloe than you are. We were the ones who took pity on her when she was a baby, and when she lay in this cave we saw that she was nursed. That girl has nothing to do with the plains or with Dryas's poor sheep. And on this occasion too we've taken thought for her welfare and ensured that she won't be carried off to be a slave in Methymna, nor become part of the spoils of war. We've asked Pan – Pan, who sits over there beneath the pine, whom neither of you has ever honoured with so much as a garland of flowers – we've asked him to be Chloe's protector,

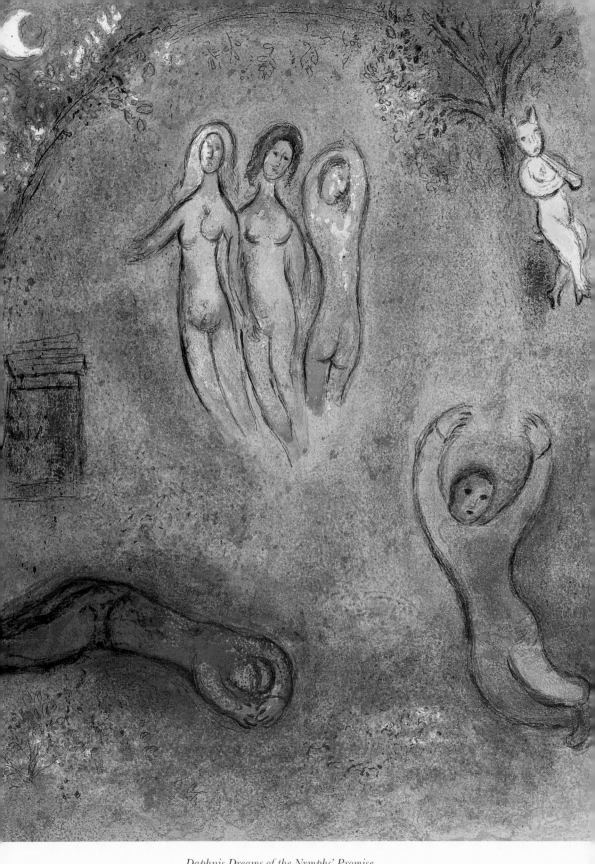

Daphnis Dreams of the Nymphs' Promise

for he's more used to life in camp than we are, and several times already he's left the countryside and gone to the wars. When he goes this time, the Methymneans won't find him at all an easy enemy to deal with. But don't be unhappy. Get up and show yourself to Lamon and Myrtale, for they, like you, are lying on the ground, thinking that you too are part of the plunder. For Chloe will come back to you tomorrow, with the goats and with the sheep; and you shall graze them together and play your pipes together. And everything else about you shall be Love's responsibility.'

When Daphnis saw and heard this, he jumped up out of his sleep and weeping for joy and sorrow simultaneously went down on his knees to the images of the Nymphs and promised to sacrifice the best of the she-goats if Chloe came back safe. He also ran to the pine where there was an image of Pan with horns and goat's legs, holding a Pan-pipe in one hand and a frisking he-goat in the other, and went down on his knees to that god too, praying for Chloe and promising to sarifice a he-goat.

At long last, when the sun was about to set, he stopped weeping and praying, picked up the leaves that he had cut, and returned to the cottage, where he relieved Lamon and his household of their anxiety and filled their hearts with joy. Then he had something to eat and went to sleep; but even in his sleep he could not stop crying, and kept on praying that he might see the Nymphs again in a dream, and praying for the day to come quickly – the day on which they had promised that Chloe would return.

Of all the nights that ever were, that night seemed the longest; and in the course of it the following events took place.

After sailing for about a mile, the Methymnean general decided to rest his soldiers as they were tired after the raid. He therefore made for a cape that jutted out into the ocean in the shape of a crescent, inside which the sea provided a natural an-

66

chorage calmer than any harbour. There he anchored his ships in deep water, so that none of them could be damaged from the land by any of the peasants, and gave the Methymneans leave to forget about the war and enjoy themselves. Because of the plunder they had taken, they were well supplied with everything they needed; so they started drinking and carousing and holding a sort of victory-celebration.

When the day was nearly over and night was putting an end to the festivities, suddenly the whole world seemed to burst into flames and a noise like the splashing of oars was heard, as though a huge fleet was sailing against them. Someone shouted to the general to prepare for battle, different people called out different things, and one man appeared to have been wounded and lay there like a corpse. It looked as if a night-battle was in progress, although there were no enemies to be seen.

This dreadful night was followed by a far more dreadful day. Flowering ivy appeared on the horns of Daphnis's he-goats and she-goats, and Chloe's rams and ewes started howling like wolves. She herself was seen to have a pine-wreath on her head. Also, in the sea itself many extraordinary things began to happen. The anchors stuck at the bottom of the sea when they tried to raise them; the oars broke when they put them in the water and tried to row; and dolphins started jumping out of the sea and banging the ships with their tails so that the planks began to come apart.

Moreover, from the steep rock above the cape the sound of a Pan-pipe was heard. But it gave no pleasure to those who heard it, as a Pan-pipe usually does; it frightened them as if it had been a trumpet. They were thrown into a panic and rushed to arms thinking that they were threatened by invisible enemies. They even prayed for night to come again, in the hope of getting a truce during the hours of darkness.

It was obvious, therefore, to any sensible person that these

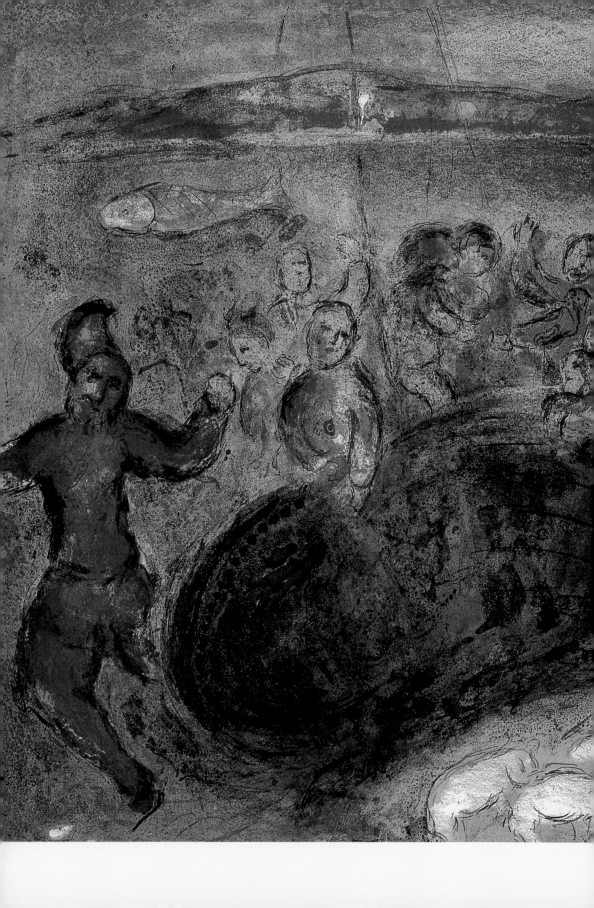

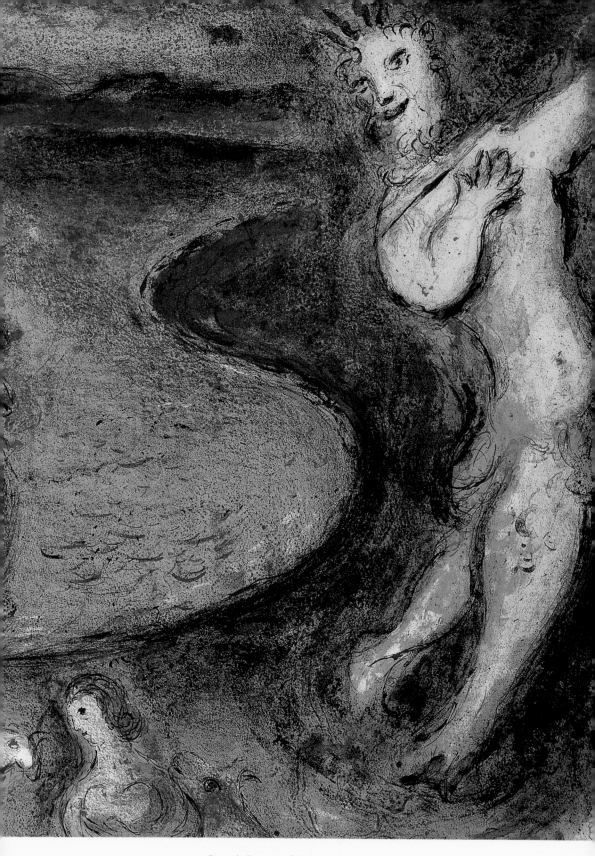

Bryaxis Dreams of Pan's Warning

strange sights and sounds were sent by Pan, and that he was angry with the sailors about something. But as no temple of Pan's had been looted, they could think of no reason for his anger until about mid-day the general providentially fell asleep, and Pan himself appeared to him and spoke as follows:

'You impious and ungodly wretches, how dare you behave in such a lunatic fashion? You've filled the countryside that I love with fighting, you've stolen herds of oxen and goats and sheep that are under my care, you've dragged away from the altar a girl whom Love has chosen to make a story about, and you've shown no reverence either for the Nymphs who witnessed the crime or for me, Pan. So if you try to sail with spoils like these on board, you'll never see Methymna and you'll never escape from this pipe, that you're so frightened of. For I'll sink you and make you food for fishes unless you in'tantly restore to the Nymphs both Chloe and Chloe's flocks, both the goats and the sheep. So up you get and put the girl ashore with the animals that I spoke of. And I will guide you on your journey by sea, and guide her on her journey by land.'

Bryaxis (for that was the general's name) was greatly alarmed. He jumped up, sent for the captains of the ships and told them to find out which of the prisoners was called Chloe. They quickly found her and brought her before him – for she was sitting with a pine-wreath on her head. Regarding this as new evidence in support of his dream, he took her ashore in his own ship. The moment she landed, the sound of a Pan-pipe was again heard from the rock. This time, however, it was not terrifying or warlike, but pastoral – like the music used to lead the flocks to pasture. Sure enough, the sheep began to run down the gangway, slipping about because of their horny hooves; but the goats made their way ashore with far greater confidence, since they were used to climbing up and down rocks. So these animals clustered round Chloe like a ring of dancers, frisking

about and bleating and showing every sign of satisfaction. But the goats belonging to the other goatherds, and the rest of the sheep and cattle stayed where they were in the ship's hold, as if the music meant nothing to them.

While everyone was staring in amazement and shouting in praise of Pan, some even more amazing sights were seen in both the elements. The Methymnean ships began to sail along before the anchors had been raised, and a dolphin led the way in front of the general's ship, jumping up and down out of the water. As for the goats and sheep, they were guided by the sound of a Pan-pipe played very sweetly – but no one saw who was playing it. Enchanted by the music, the sheep and goats moved forward all together and began to graze.

It was about the time of the second pasturing when Daphnis, who had climbed up to a high place and was on the look-out, caught sight of Chloe and the flocks.

'Oh, Nymphs and Pan!' he exclaimed alound, and ran down on to the plain where he flung his arms round Chloe and – fell down in a dead faint. When Chloe's kisses and the warmth of her embraces had at last brought him back to life, he went under their usual oak-tree, sat down against the trunk and asked how she had managed to escape from such a strong enemy force. So she told him all about the ivy on the goat's horns, the howling of the sheep, the sprouting of the pine on her own head, the fire on land, the noises at sea, the two sorts of piping, the warlike and the peaceful, the dreadful night that she had had – and how, though she did not know the way, music had guided her home.

Realizing that Pan had made his dream about the Nymphs come true, Daphnis in his turn began to relate all that he had seen and heard, and how when he meant to die, the Nymphs had kept him alive. After that he sent off Chloe to fetch Dryas and Lamon and their families, and to bring what was needed for a sacrifice. Meanwhile he caught the best of the she-goats,

wreathed it with ivy, just as all the goats had been wreathed when the enemies saw them, and poured a libation of milk over its horns. Then he sacrificed it to the Nymphs, and after hanging it up and skinning it presented the skin as a votive-offering.

By this time Chloe and the others had arrived, so he lit a fire and boiled some of the meat and roasted the rest. He offered the firstlings to the Nymphs and poured out a bowlful of must as a libation. Then they all heaped up beds of leaves and from then on gave their minds to eating and drinking and enjoying themselves. At the same time they kept an eye on the flocks, to make sure that no wolf pounced on them and did what the enemies had done. They also sang songs to the Nymphs, composed by shepherds of long ago. And when night fell, they slept where they were in the field.

Next day they turned their thoughts to Pan. They put a pine-wreath on the he-goat that was the leader of the herd, took him to the pine, and after pouring wine over him and shouting in honour of the god sacrificed the victim, hung it up and skinned it. When they had roasted and boiled the meat, they placed it on the leaves in the meadow close by; but the skin they attached by its own horns to the pine beside the image, as a pastoral offering to a pastoral god. They also offered him the firstlings of the meat and poured an even larger bowlful of wine as a libation. Chloe sang, and Daphnis played his pipe.

After this they lay down and had just started eating when Philetas the cowherd turned up; for he happened to be bringing some garlands for Pan, and some bunches of grapes still attached to the leafy vine-shoots. He was accompanied by his youngest son, Tityrus, a child with red hair, blue eyes, white skin, and a great deal of spirit, who capered about as he walked, just like a kid.

So up they jumped and after helping Philetas to put the garlands on Pan and hang up the vineshoots among the leaves of

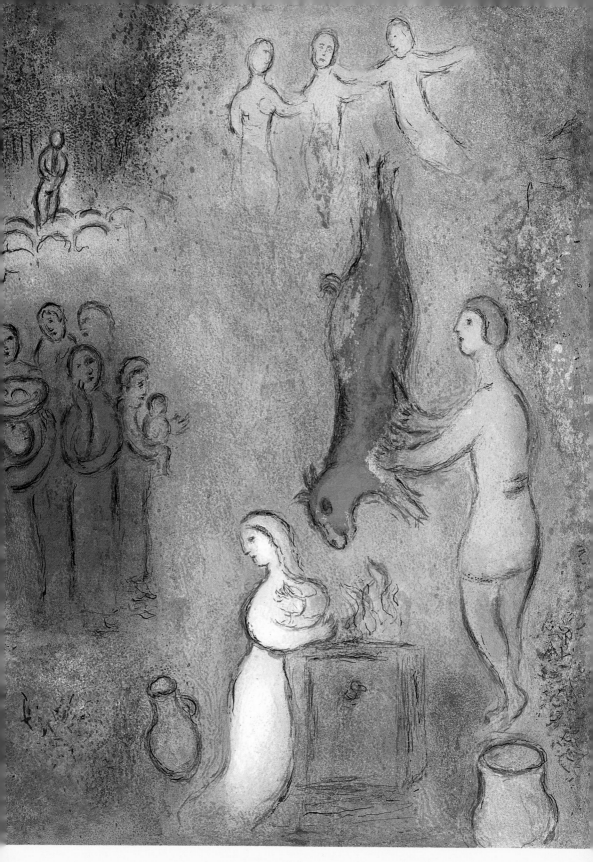

Sacrifice to the Nymphs

the tree they made him lie down beside them and join the party.
Then the old men, who were getting slightly tipsy, started chat-
tering away to each other about how well they had looked after
their flocks when they were young, and how many raids by
pirates they had survived. One man boasted of having killed a
wolf, another of having played the Pan-pipe better than anyone
except Pan. This boast came from Philetas.

So Daphnis and Chloe begged him very earnestly to impart
some of his skill to them and, since the feast was being held in
honour of a god who loved the pipe, to give a display of piping.
Philetas promised he would (though he complained that he was
getting old and short of breath) and they gave him Daphnis's
pipe; but it was too small to do justice to a great talent like his, as
it was only meant for a boy to play on. Tityrus was therefore des-
patched to fetch his father's own pipe from the cottage, which
was about a mile away; so he flung off his apron and darted away
in nothing but his vest, running as swiftly as a fawn. Meanwhile
Lamon promised to tell them a story that a Sicilian goatherd had
sung to him for the price of a he-goat and a Pan-pipe – the story
of the Pan-pipe itself.

'This Pan-pipe of ours was originally not a musical instru-
ment but a beautiful girl who had a lovely voice. She used to
graze goats and play with the Nymphs and sing – just as she does
now. While she was grazing and playing and singing, Pan came
up to her and tried to talk her into doing what he wanted by
promising to make all her she-goats have twins. But she laughed
at his love and said she didn't want a lover who was neither one
thing nor the other – neither a goat nor a man. So Pan started
chasing her with the intention of offering her violence. She
started running away, and when she was tired of running away
from Pan and his violence she hid among some reeds and disap-
peared into a marsh. Pan angrily cut the reeds – but he didn't
find the girl. So profiting by this experience he fastened some of

74

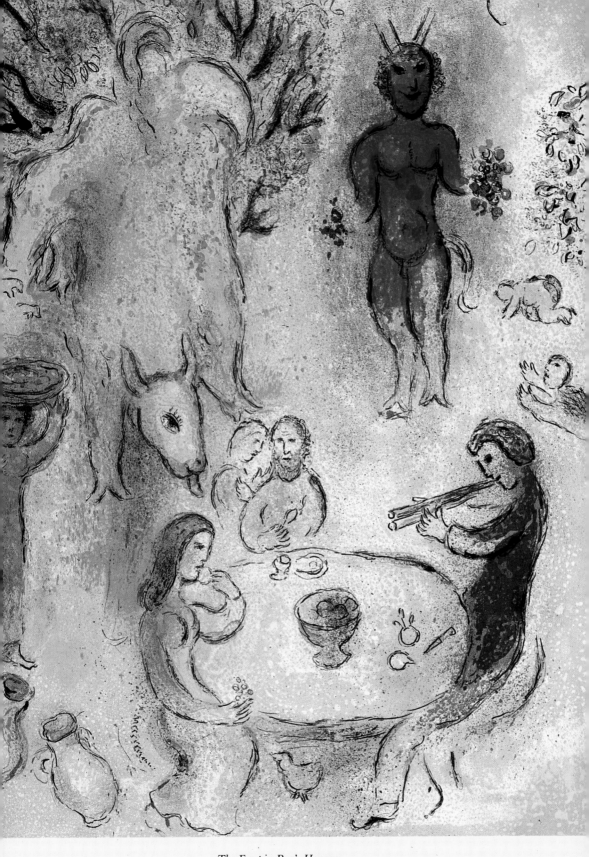

The Feast in Pan's Honour

the reeds together with wax – using reeds of unequal length since even Love had proved unequal to them – and thus invented the musical instrument. And what was once a beautiful girl is now the sweet Pan-pipe.'

Lamon had just finished his story and Philetas was congratulating him on having told a tale sweeter than any song, when Tityrus appeared carrying his father's Pan-pipe, a big instrument made of big reeds and decorated with bronze at the places where it was fastened with wax. You would have taken it for the very pipe that Pan originally made.

So Philetas roused himself, and got up and sat on a chair. First of all he tested the reeds to see if they were in proper condition for playing. Then, having made sure that the air could pass freely through them, he began to play with a loud and powerful tone. You would have thought you were listening to several flutes playing in unison, so great a volume of sound did he produce. Then with a gradual *diminuendo* he changed to a sweeter tune, and showing his skill in every form of pastoral melody he played music that would be suitable for a herd of cattle, music that would be appropriate for goats, and music that would appeal to a flock of sheep. The tune for sheep was sweet, the tune for cattle was loud, and the tune for goats was shrill. In short, with that one pipe he imitated all the pipes in the world.

The others lay in silence enjoying the music – all except Dryas, who got up and calling for a Bacchic tune on the pipe performed a dance expressive of the vintage. First he pretended to be picking fruit, then to be carrying baskets, then to be treading down the grapes, then to be filling the wine-jars, and finally to be drinking the new wine. He mimed all these operations so gracefully and vividly that his audience could almost see the vines and the wine-presses and the wine-jars, and had the impression that Dryas was actually drinking.

So it was by dancing that this third old man distinguished

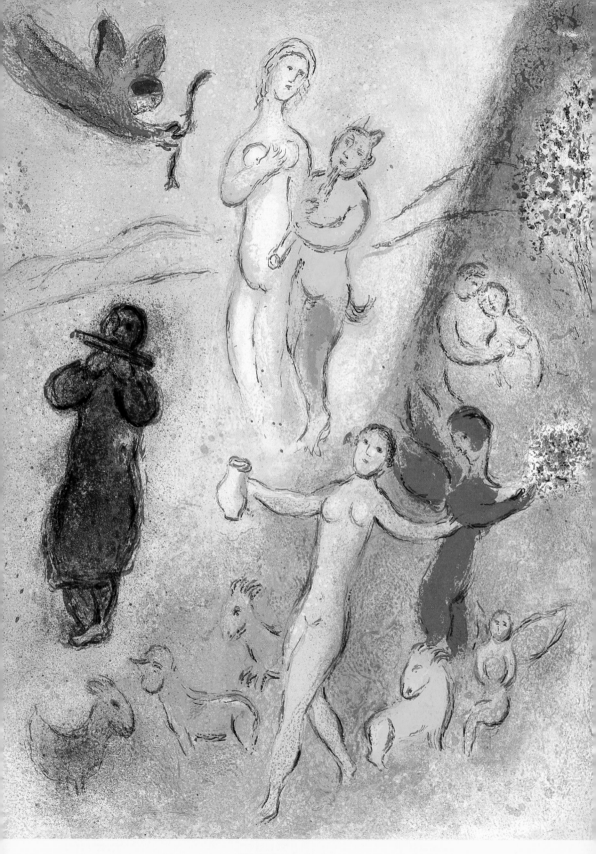

The Syrinx Legend

himself, after which he kissed Chloe and Daphnis, who prompt-
ly sprang to their feet and performed a dance based on Lamon's
story. Daphnis took the part of Pan, and Chloe of the girl who
became the Pan-pipe. First he pleaded persuasively and she
smiled in disdain. Then he started to chase her, running on tip-
toe to give the impression of having hooves, and she pretended
to be worn out with running away. Then Chloe hid in the wood
– which was meant to represent the marsh – and Daphnis seized
Philetas's big pipe and played a melancholy tune to express Pan's
love, a romantic tune to express his wooing, and a tune that
seemed to say 'Come back!' to express his pursuit. Philetas was
much impressed. He jumped up and kissed Daphnis, and gave
him the pipe to keep, begging him to leave it to an equally
worthy successor. So Daphnis presented his little one as an offer-
ing to Pan, and after kissing Chloe as warmly as if she had run
away in earnest and he had found her again, he used the pipe to
lead his flock home, since night was now falling.

Chloe too used the music of the Pan-pipe to collect her sheep
and started driving them home. The goats went along with the
sheep, and Daphnis walked beside Chloe. Thus they feasted on
each other's company until it was dark, and agreed to drive their
flocks out earlier than usual next morning.

And so they did – in fact day was only just breaking when
they arrived at the pasture. After paying their respects first to
the Nymphs and then to Pan, they sat down under the oak and
played their pipes. Then they started kissing, embracing, lying
down together – and having gained nothing by it, got up again.
They also turned their thoughts towards food, and had a drink
of wine mixed with milk.

All this heated their blood and gave them greater confid-
ence, and they began to argue about their love for one another.
Finally they got to the point of swearing oaths that what they
said was true. Daphnis went to the pine and swore by Pan that he

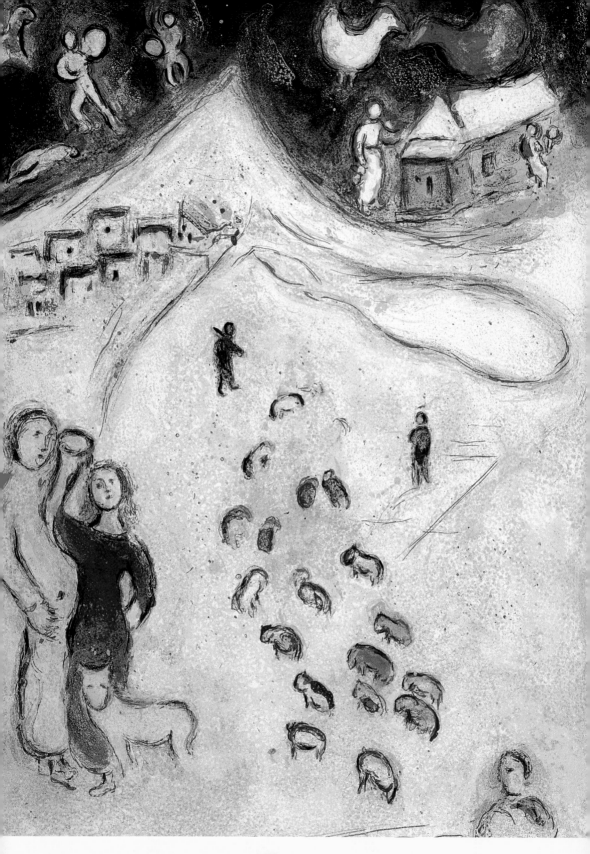

Winter

would not live a single day if Chloe left him; and Chloe went into the cave and swore by the Nymphs that all she wanted was to live and die with Daphnis. But such was Chloe's girlish simplicity that as she was leaving the cave she demanded a second oath from him as well.

'Oh, Daphnis,' she said, 'Pan's a god who's always falling in love and breaking faith. He was in love with the girl who was turned into a pine, and he was in love with the girl who was turned into a Pan-pipe and he never stops pestering the Wood-Nymphs and making himself a nuisance to the Nymphs who protect the flocks. So if you swear by him and fail to keep your oath, he'll fail to punish you – even if you go after more women than there are reeds in a pipe. Swear by this herd of goats and by the she-goats that suckled you never to desert Chloe so long as she remains faithful to you. But if she ever wrongs you and the Nymphs, you may cast her off and hate her and kill her, just as you would a wolf.'

Daphnis was very pleased to be distrusted. He went and stood in the middle of the herd of goats, and taking hold of a she-goat with one hand and a he-goat with the other swore that he would love Chloe as long as she loved him. And if she ever preferred another man to Daphnis, he swore that he would kill, not her, but the other man. Chloe was delighted and entirely convinced; for being a shepherd-girl, she regarded goats and sheep as the proper gods for shepherds and goatherds to swear by.

Third Book

WHEN the people of Mytilene heard of the attack by the ten ships and reports came in from the fields of the plunder that had been taken, they thought it quite intolerable to be treated like that by the Methymneans and decided to make a counter-attack as quickly as possible. They therefore mobilized three thousand infantry and five hundred cavalry and sent them off, under the command of Hippasos, their general, by land – for they did not trust the sea during the winter.

So off he went; but he made no attempt to plunder the fields of the Methymneans or rob the farmers and shepherds of their livestock and possessions, for this seemed to him more like piracy than strategy. Instead, he quickly marched against the city itself, in the hope of forcing the gates before they were properly guarded. When he was about eleven miles away, a herald came to meet him with overtures of peace; for the Methymneans had learnt from their prisoners that the citizens of Mytilene knew nothing of what had happened, and that the only people concerned had been a handful of farmers and shepherds who had merely punished the young men for their outrageous behaviour. So they regretted their imprudence in taking such hasty action against a neighbouring city, and were anxious to restore all the plunder and enjoy safe communications by sea and land.

Although Hippasos had been elected general with full powers to make his own decisions, he sent the herald on to Mytilene, while he himself pitched camp about a mile from Methymna and awaited further orders. Two days later a message arrived telling him to recover the stolen property and return home without doing any damage; for since they had the choice between war and peace, they decided that peace would pay them better.

Thus ended the war between Methymna and Mytilene, finishing as unexpectedly as it began.

Winter now came on, which was even worse for Daphnis and Chloe than the war had been; for suddenly there was a great fall of snow which blocked all the roads and shut up all the country people in their homes. Swollen torrents came rushing down, and everything froze solid. The trees looked as if they were at breaking-point, and the ground was completely invisible except for some places round springs and streams. No one either drove a flock to pasture or went out of doors himself. Instead, they lit great fires at cock-crow and started spinning flax or weaving goathair or making ingenious snares for birds. At the same time they had to make sure that the cattle at the mangers had bran to eat, that the goats and sheep in the folds had leaves, and that the pigs in the sties had various kinds of acorn.

Now that everyone was forced to stay at home, the other farmers and shepherds were delighted to have a short holiday, and have a meal in the morning, and sleep late; so to them the winter seemed pleasanter than either summer or autumn or spring itself. But Chloe and Daphnis, remembering the pleasures they had left behind them, their kisses and embraces and meals together, passed sleepless nights and miserable days, and looked forward to the spring as to a resurrection from death.

They felt miserable every time they came across a knapsack from which they had eaten food together, or caught sight of a milk-pail from which they had drunk together, or a Pan-pipe thrown carelessly away, which had been a lover's gift. So they prayed to the Nymphs and Pan to save them from these miseries too, and give them and their flocks a glimpse of the sun at last. And all the time they were praying, they were trying to think of a way of seeing one another. Chloe was terribly at a loss and did not know what to do, for her so-called mother was always with her, teaching her to card wool and turn the spindle, and talking

about marriage. But Daphnis, who had plenty of time and more ingenuity than you would expect from a girl, devised the following method of seeing Chloe.

In front of Dryas's cottage, right under the cottage itself, two myrtles and some ivy had taken root. The myrtles were close together and the ivy was in between. It branched out over each of them like a vine, and with its interlacing leaves created a sort of cave inside which many clusters of berries, as big as bunches of grapes, hung down from the branches. Crowds of birds used to collect there in the winter, as they could not find any food outside – lots of blackbirds, lots of thrushes, wood-pigeons, starlings, and all the other birds that eat ivy.

So one day Daphnis started out, with the ostensible object of catching some of these birds. He had filled his knapsack with honey-cakes, and carried bird-lime and snares to make his story more convincing. The distance he had to cover was not more than a mile but the snow, which had not yet melted, gave him a great deal of trouble. Love, however, can find a way through anything – fire, or water, or Scythian snow. So he ran all the way to the cottage, and after shaking the snow off his legs he set the snares and smeared the bird-lime over some long twigs and then sat down to wait for the birds – and Chloe. The birds arrived in large numbers, and enough of them were caught to keep him hard at work collecting them and killing them and pulling off their wings. But no one came out of the cottage – not a man, not a woman, not a domestic fowl. They were all shut up indoors, keeping close to the fire. So Daphnis was completely baffled and felt that the birds he had come to catch must be birds of ill-omen. Then he made up his mind to invent some excuse and push boldly through the door; and he began to ask himself what would be the most plausible thing to say.

'I've come to get a light for a fire.'

'Why, hadn't you got neighbours only a hundred yards away?'

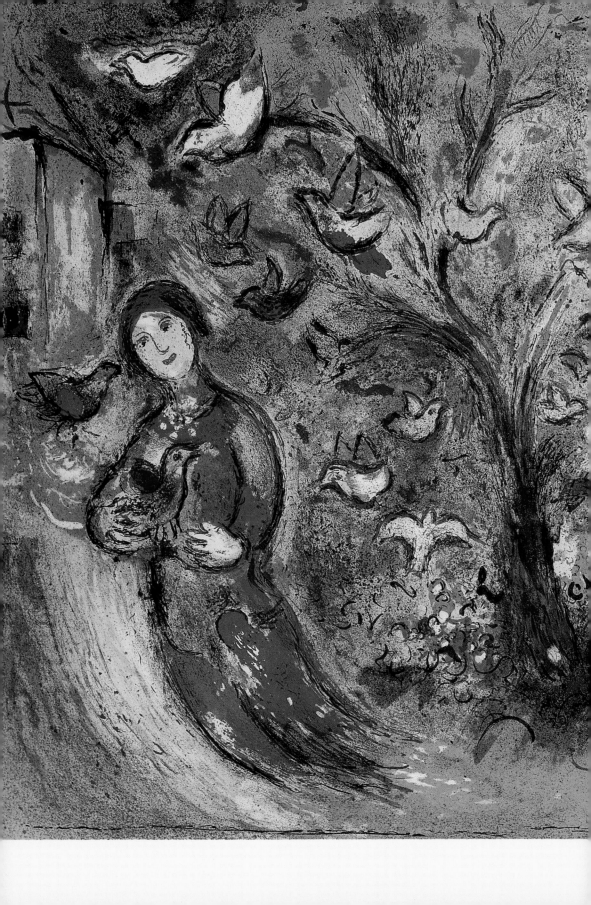

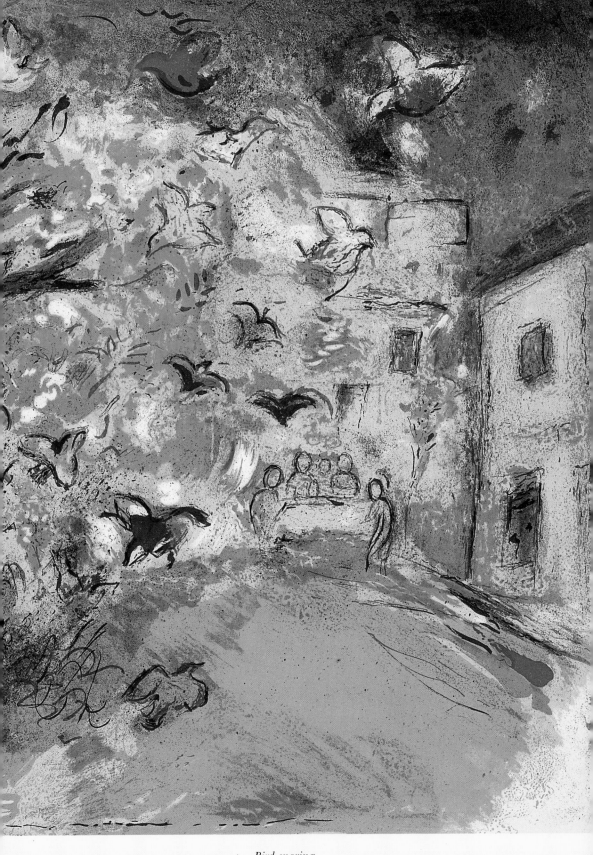

Bird-snaring

'I've come to ask for some bread.'

'But your knapsack's full of food already.'

'I want some wine.'

'Yet only a day or two ago you were busy with the vintage.'

'A wolf's been chasing me.'

'Oh? And where are the wolf's footprints?'

'I've come to catch the birds.'

'Well, now you've caught them, so why don't you go away?'

'I want to see Chloe.'

'Who admits a thing like that to a girl's father and mother?'

'Oh, I'll put my foot in it whatever I do, and then be struck dumb. Every single one of these excuses sounds suspicious – so I'd better not say anything. And I'll see Chloe in the spring, since apparently I'm not fated to see her during the winter.'

After some such thoughts as these he collected the birds that he had caught, and had just started to go away when, as if Love had taken pity on him, the following series of events took place.

Dryas and his family were busy round the table. Meat was being carved, bread was being handed out, and wine was being mixed in a bowl. Just then one of the sheep-dogs, after waiting until no one was looking, grabbed some meat and fled through the door. Dryas was annoyed, for it was his own helping; so he grabbed a stick and did what another dog would have done – dashed off in pursuit. In the course of this pursuit he came to the ivy and saw Daphnis, who had just hoisted his catch on to his shoulders and decided to be off. So Dryas immediately forgot about the meat and the dog, and called out:

'Good day to you, my boy!'

He flung his arms around Daphnis, kissed him affectionately and seizing his hand led him indoors.

When they saw one another they very nearly sank to the ground; but managing with an effort to stay upright they wished one another good morning and kissed each other –

which gave them some sort of support and prevented them from falling.

Thus Daphnis got more than he had hoped for – not only a glimpse of Chloe but a kiss as well. He sat down close to the fire and unloaded the wood-pigeons from his shoulders on to the table, and the blackbirds, and described how he had got sick of staying at home and had gone out to catch birds; and how he had caught some of them with snares and the rest with bird-lime while they were gobbling up the myrtle-berries and ivy.

They praised him for being so energetic and invited him to dinner – what was left of it after the dog had finished. And they told Chloe to give him a drink. Delighted as she was, she served the others first and Daphnis last of all; for she was pretending to be annoyed because, having come so near, he had meant to run away without seeing her. But before giving him his wine, she drank a sip of it herself; and only then did she pass it to him. And he drank slowly, although he was very thirsty, and thus by his slowness prolonged his enjoyment.

The bread and meat soon disappeared from the table; but they went on sitting there and asked after Myrtale and Lamon, and congratulated them on their good fortune in having some-one like Daphnis to support them in their old age. Daphnis was delighted enough to be praised in Chloe's hearing, but when they asked him to stay the night, as they were going to make a sacrifice to Dionysus on the following day, his delight was such that he very nearly went down on his knees, not to Dionysus, but to them. So he promptly produced from his knapsack a large supply of honey-cakes, and also the birds that he had caught; and these they started to prepare for supper.

Another bowlful of wine was mixed, another fire was lighted. Very soon it was dark, and they started to eat another meal; after which they spent part of the time telling stories and part of it singing songs until they went to bed, Chloe with her

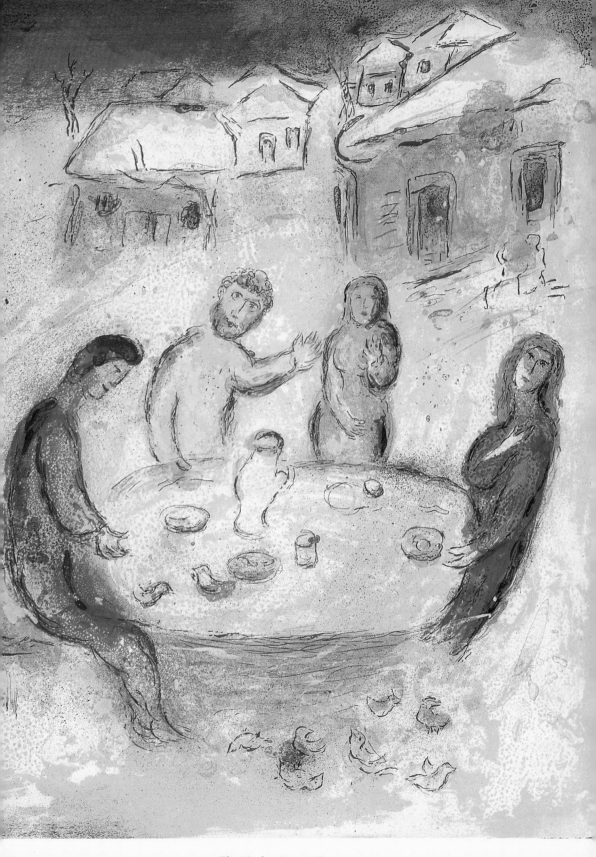

The Meal at Dryas's House

mother, and Dryas with Daphnis. So Chloe got nothing out of it, except that she was going to see Daphnis the following day. But Daphnis derived some imaginary pleasure from the arrangement, for he thought it very pleasant even to go to bed with Chloe's father – with the result that he kept embracing Dryas and kissing him, dreaming that he was doing it all to Chloe.

When day came it was intensely cold and there was a biting North wind. But up they got and sacrificed a one-year-old ram to Dionysus. Then after lighting a big fire they started preparing food. So while Nape was making bread and Dryas was boiling the ram, Daphnis and Chloe seized the opportunity to go outside the cottage to where the ivy was. Again they set snares and smeared bird-lime, and caught a number of birds. They also indulged in a continuous series of kisses and had some pleasant conversation.

'It was because of you that I came, Chloe.'

'I know, Daphnis.'

'It's because of you that I'm killing those poor blackbirds.'

'Well, what do you want me to do about it?'

'I want you to remember me.'

'By the Nymphs that I once swore by in that cave, I *do* remember you! And we'll go there the moment the snow melts.'

'But there's so *much* snow, Chloe, and I'm afraid I'll melt away before it does.'

'Cheer up, Daphnis. The sun's hot enough.'

'Oh, Chloe, if only it were as hot as the fire that's burning my heart!'

'You're only joking and deceiving me.'

'By the goats that you made me swear by, I'm not!'

Chloe echoed back what Daphnis had just said and then, as Nape was calling them, they ran indoors taking with them a far bigger catch than yesterday's. After offering the first few drops from the winebowl to Dionysus, they put crowns of ivy on their

heads and began to eat. When the time came, they shouted,
'Hurrah for Dionysus!' and saw Daphnis off, after filling his
knapsack with meat and bread. They also gave him the wood-
pigeons and the thrushes to take to Lamon and Myrtale, saying
that they could always catch some more for themselves, as long
as the bad weather continued and the ivy did not fail. So off he
went, kissing them first and Chloe afterwards, to ensure that
her kiss remained undiluted.

After that he made several other visits on other pretexts;
and so their winter was not wholly devoid of love.

It was now the beginning of spring. The snow was melting,
the earth was being laid bare, the grass was beginning to grow.
So all the shepherds started leading their flocks to pasture, and
Chloe and Daphnis went first, since they were in the service of
the greatest shepherd of all. They ran off at once to the Nymphs
in the cave, then to Pan by the pine, and then to the oak-tree,
under which they sat down and started grazing their flocks and
kissing one another. Then, wishing to put garlands on the gods,
they made a search for flowers. These were only just coming
out, nursed by the west wind and warmed by the sun; but even
so there were violets to be found, and narcissi and pimpernels
and all the first-born of the spring. With these they wreathed the
images, and then they poured libations of fresh milk from
Chloe's ewes and Daphnis's goats. They also offered up the first-
fruits of the Pan-pipe, as if they were challenging the nightin-
gales to song; and the nightingales began to reply from the
thickets, becoming gradually more proficient at their dirge for
Itys, as if they were gradually remembering the tune after their
long silence.

Here and there sheep were bleating and lambs were skip-
ping about, then kneeling under their mothers and tugging
away at the teat. As for the ewes that had not yet lambed, the
rams were chasing them until first one ram and then another

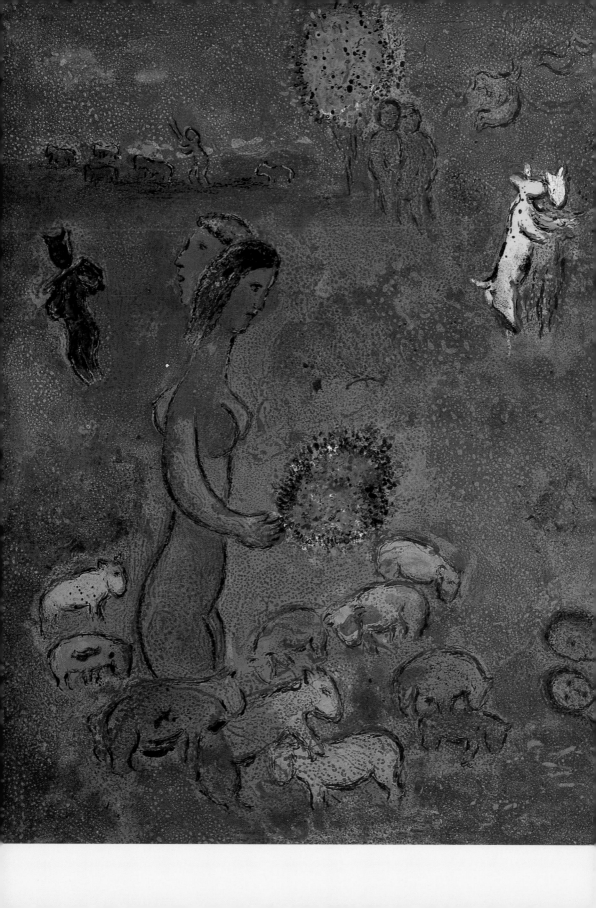

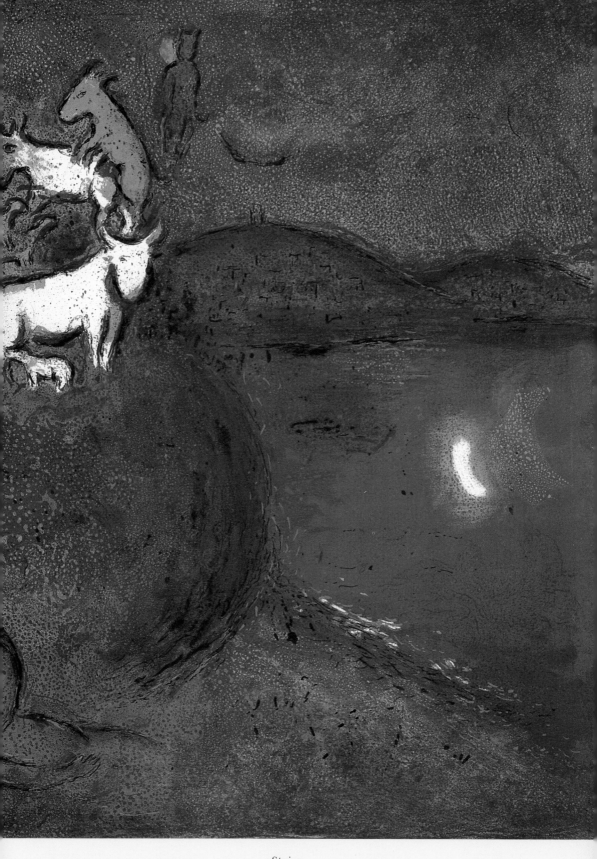

Spring

caught his ewe; and the he-goats were pursuing the she-goats with even greater ardour. They were also fighting over them, for every he-goat had his own wives and was always on his guard against adulterers. It was a sight calculated to turn even an old man's thoughts to love; but Daphnis and Chloe, who were young and bursting with health and had long been in search of love, were positively set on fire by what they heard, their hearts melted away at what they saw, and they too felt the need for something more than kisses and embraces – Daphnis especially, for he had been wasting his youth all the winter, sitting drearily at home. So now he hungered for kisses, lusted for embraces, and was far more bold and enterprising about the whole business.

He asked Chloe if she would, as a favour, do exactly what he wanted and let them lie together naked much longer than they had ever done before (since this was the only part of Philetas's instructions that had not been carried out) in order to try the one remedy for love that really worked.

'But what more can there be,' she asked, 'than kissing and embracing and actually lying down? What do you mean to do when we're lying together naked?'

'What the rams do to the ewes,' he replied, 'and what the he-goats do to the she-goats. Haven't you noticed that when they've done it the she-goats stop running away from the he-goats and the he-goats stop having the trouble of chasing them? From then on, they graze side by side as if they'd shared some pleasure between them. Apparently what they do is something very sweet which takes away the bitterness of love.'

'But Daphnis, haven't *you* noticed that the rams and the he-goats do it standing up, and the ewes and the she-goats have it done to them standing up? The males jump on top of the females from behind. Yet you want me to lie down beside you – and without any clothes on either, though you can see how much hairier they are than me, even when I'm dressed!'

However, she did as he asked, and Daphnis lay down beside her, and stayed there for a long time; but having no idea how to do what he passionately wanted to do, he made her get up again and, following the example of the he-goats, tried embracing her from behind. Then, feeling more baffled than ever, he sat down and burst into tears, to think that any sheep knew more about love than he did.

He had a neighbour called Chromis, who farmed his own land. Chromis, though physically past his prime, had imported a wife from town who was young and pretty and by country standards rather elegant. Her name was Lycaenion. Seeing Daphnis go past every morning as he drove his goats to pasture, and every evening as he drove them back, Lycaenion set her heart on having him as a lover, and planned to win him over by giving him presents. So she waylaid him one day when he was by himself, and presented him with a Pan-pipe, some honey in a honey-comb, and a deerskin knapsack. But guessing his love for Chloe she hesitated to say anything; for she saw that he was completely devoted to the girl.

She had suspected this before from various nods and smiles that passed between them; but on this particular day she had gone out early in the morning, pretending to Chromis that she was visiting a neighbour who was having a baby, and followed close behind Daphnis and Chloe. She had hidden in a thicket so as not to be seen, and had heard all they said and watched all they did; nor had she failed to observe how Daphnis burst into tears. Feeling sorry for the wretched pair and thinking that her chance had come to put things right for them and at the same time to satisfy her own desires, she devised the following scheme. Next day, pretending that she was going to visit the woman again, she openly approached the oak-tree where Daphnis and Chloe were sitting and gave an accurate imitation of a damsel in distress.

'Oh, Daphnis, please come to the rescue,' she said, 'I'm so miserable – an eagle's carried off the finest of my twenty geese. It was so heavy to carry that he couldn't get it up to his usual high rock over there, and he landed down here in the wood with it. So I beg you, in the name of the Nymphs and Pan there, to come with me into the wood, for I'm afraid to go by myself. Please rescue my goose and don't let me be one short! And perhaps you'll be able to kill the eagle as well and stop him carrying off a lot of your lambs and kids. Chloe can look after the flock in the meantime. The goats must konw her well enough – she's always helping you graze them.'

So having no idea what was going to happen, Daphnis immediately rose, picked up his shepherd's staff, and went after Lycaenion. She led him as far away from Chloe as possible, and when they were in the thickest part of the wood she told him to sit down beside a spring.

'Daphnis,' she said, 'you're in love with Chloe. The Nymphs told me so last night in a dream. They described how you burst into tears yesterday, and ordered me to come to your rescue by teaching you how to make love. And making love doesn't just mean kissing and embracing and doing what the rams and he-goats do. It means a form of intercourse quite different from theirs and far sweeter – for the pleasure lasts longer. So if you want to stop being miserable and experience the delights that you've been looking for, come, put your delightful self into my hands and become my pupil – and I, to please the Nymphs, will teach you what you need to know.'

Daphnis was beside himself with joy. He did what any peasant, any goatherd who was young and and in love would have done: he fell down at Lycaenion's fet and begged her to lose no time in teaching him how to do what he wanted to do to Chloe. He behaved exactly as if he had been about to receive some great revelation from a god; for he promised to give her a kid,

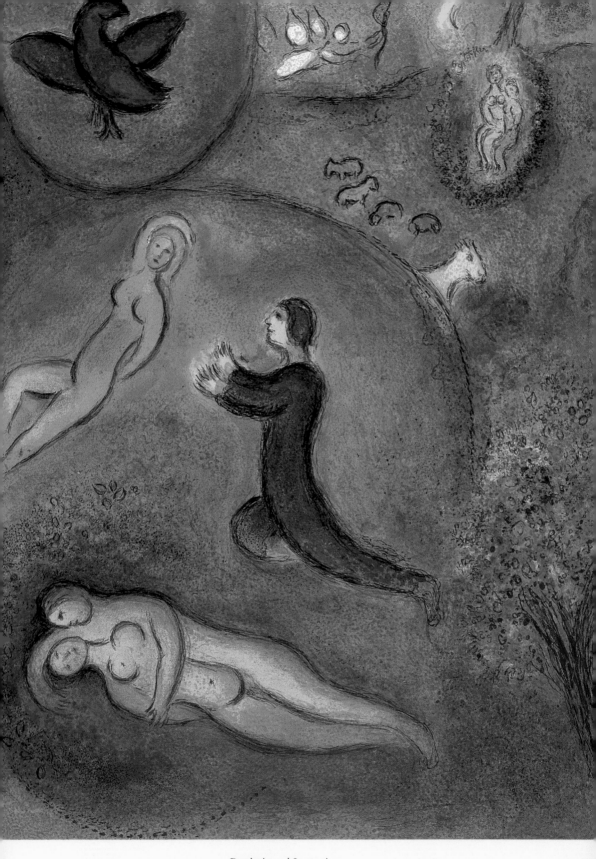

Daphnis and Lycaenion

and some delicious cheeses made from a she-goat's first yield of milk, and the she-goat herself as well.

Encouraged by such unexpected innocence, Lycaenion began to educate Daphnis as follows. She told him to sit down beside her, just as he was, and start kissing her in a quite ordinary way. Then, while still kissing her, he was to take her in his arms and lie down on the ground. So Daphnis sat down, and started kissing her, and after a while lay down; and when she felt him get big and ready for action, she raised him up from where he lay on his side, slipped her body under his, and deftly guided him into the passage that he had been trying so long to find. After that she made no special efforts; for Nature herself taught Daphnis all that remained to be done.

When the lesson in love-making ended, Daphnis was still enough of a goatherd to feel like rushing back to Chloe, and immediately putting his new knowledge into practice – as though he were afraid of forgetting it, if he wasted any time. But Lycaenion stopped him by saying:

'Daphnis, there's something else that you should know. I happen to be an experienced woman, so it didn't hurt me in the least just now – for I had my first lesson long ago from another man, who took my virginity as his fee. But if you try this sort of wrestling-match with Chloe, she'll scream and burst into tears, and lie there streaming with blood, as though you'd murdered her. But don't you worry about the blood. When she agrees to let you have her, bring her out here, so that if she screams, nobody will hear, and if she cries, nobody will see, and if she gets covered with blood, she can wash it off at that spring. And remember, I made a man of you before Chloe ever did.'

Having given him this advice, Lycaenion went off to another part of the wood, as though still in search of her goose. When he thought over what she had said, Daphnis found he had lost all his original enthusiasm, and felt reluctant to bother Chloe with

anything more than kissing and embracing; for he did not want her to scream at him as if he were an enemy, or cry as if she were hurt, or stream with blood as if he had murdered her. He was particularly frightened of the blood, for this was the first he had heard of it, and he assumed that bleeding must mean a wound.

So having made up his mind to go on enjoying himself with Chloe in the usual way, he emerged from the wood, went to where she sat weaving a crown of violets, and told her a story about having snatched the goose out of the eagle's talons. Then he put his arms round her and gave her the sort of kiss that he had given Lycaenion when he was enjoying himself with her; for kissing was allowed – there was nothing dangerous about that.

Chloe put the crown on his head and kissed his hair, thinking it far more beautiful than the violets. Then she produced a piece of fruit-cake and some bread from her knapsack and gave him them to eat; and while he was eating she snatched pieces from his mouth and ate them herself, just like a young bird.

While they were busy eating – and even busier kissing – they saw a fishing-boat sailing past. There was no wind and the sea was calm, so the fishermen had decided to row. They were rowing very hard, for they were in a hurry to get their latest catch to a certain rich man in the city while the fish were still fresh. So as they raised and lowered their oars they were doing what seamen usually do to take their minds off their work: one man, the cox, was singing sea-shanties to them, and the rest were keeping in time with him and shouting the choruses in unison.

Now when they did this in the open sea, their shouting was inaudible from land, because their voices flowed out into a huge space of air. But when they ran under a certain cape and entered a crescent-shaped, land-locked bay, the shouting could be heard quite loud and the songs that kept the rowers together came clearly to the land; for there was a hollow glen just opposite which acted as a sort of resonator and after taking the sounds

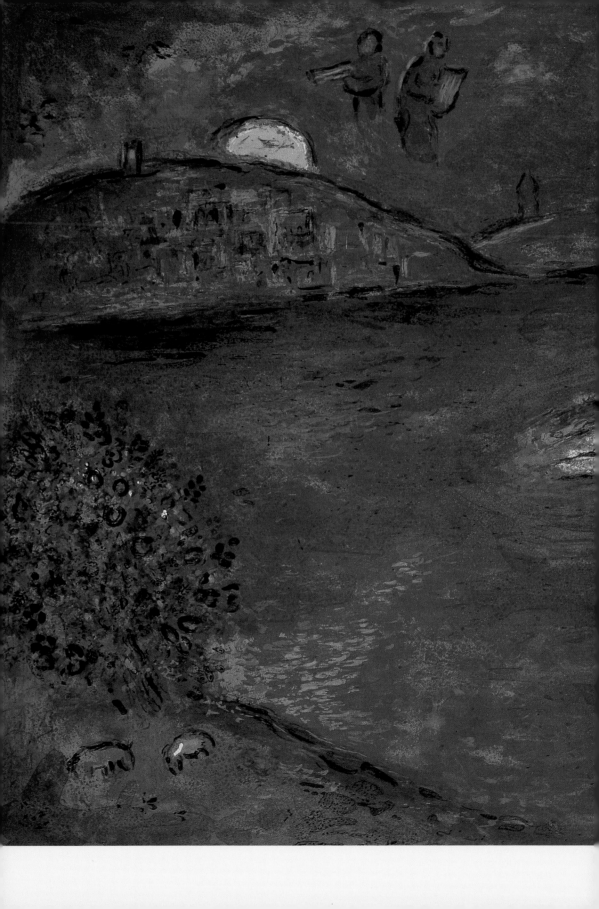

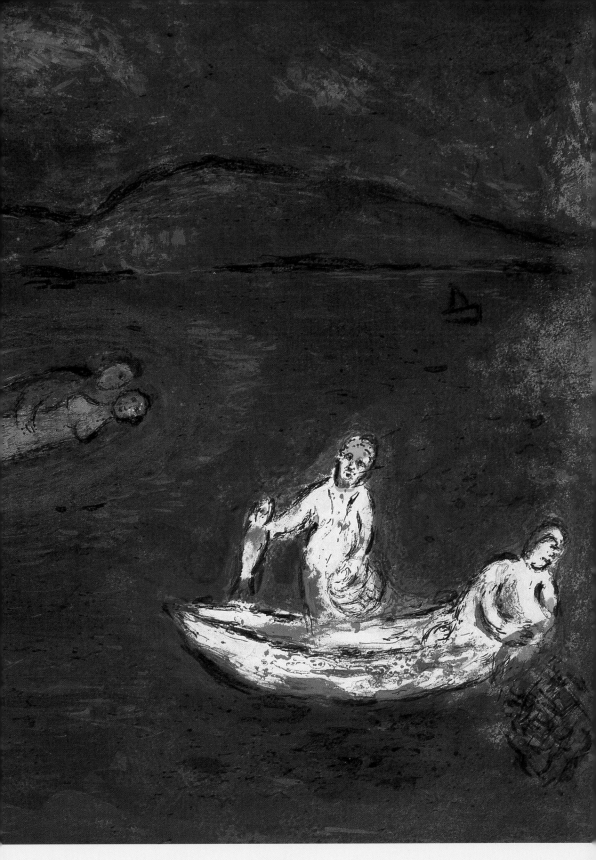

The Echo

into itself reproduced everything that was said and done, the noise of the oars and the singing of the seamen, each separate and distinct. It was very pleasant to listen to, for the voices from the sea came first and the voices from the land began and ended later.

Now Daphnis knew what was happening, so he kept his thoughts on the sea and enjoyed watching the boat glide past the plain more swiftly than a bird, and tried to memorize some of the tunes so that he could play them on his pipe. But it was Chloe's first experience of what is called an echo, so one moment she would be looking out to sea while the seamen were calling the time, the next she would be turning round towards the wood to see where the answering voices were coming from. And when the fishermen had sailed past and there was no sound either from them or from the glen, she asked Daphnis:

'Is there more sea the other side of the cape? And is there another boat sailing along with other seamen singing the same songs? And have they all stopped singing at the same time?'

So Daphnis laughed pleasantly, and gave her a kiss which was even more pleasant, and put the crown of violets on *her*. Then he began to tell her the story of Echo, after stipulating that he should be paid a fee of ten more kisses, when he had taught it to her:

'There are, dear girl, several kinds of Nymph. There are the Nymphs of the Ash, the Nymphs of the Oak, and the Nymphs of the Meadow. All of them are beautiful and all are musical. Well, one of these Nymphs had a daughter called Echo, who was mortal because her father was mortal, but beautiful because her mother was beautiful. She was brought up by the Nymphs and taught by the Muses to play the pipe and the flute, to perform upon the lute and the lyre, and to sing songs of every kind. So when she grew up and reached the flower of girlhood, she used to dance with the Nymphs and sing with the Muses. But she

avoided all males, whether human or divine, for she loved virginity. Pan grew angry with the girl, partly because he envied her gift for music, and partly because he had failed to enjoy her beauty. So he sent the shepherds and goatherds mad, and they like dogs or wolves tore her to pieces and scattered her limbs about the whole earth – or rather scattered her hymns, for she still went on singing. As a favour to the Nymphs, the Earth concealed these singing limbs and preserved their music; and they, by order of the Muses, are still able to sing and imitate sounds of every kind, just as the girl did once – sounds made by gods, by men, by musical instruments, and by wild beasts. They even imitate Pan when he plays his pipe, and he, when he hears them, jumps up and goes rushing over the mountains in pursuit. But the only love that he pursues is Knowledge – he would love to know who his invisible imitator is.'

When Daphnis had told this story Chloe kissed him, not merely ten times, but very often indeed; for Echo had repeated almost everything he said, as if to testify that he was telling the truth.

The sun was growing hotter every day, for spring was coming to an end and summer was beginning; so again they found new pleasures, this time summery ones. He would swim in the rivers and she would bathe in the springs; he on his pipe would compete with the whistling of the wind in the pines, and she would vie with the nightingales in song. They hunted chattering locusts and caught noisy grasshoppers; they collected flowers, and shook trees and ate the fruit. And now at last they actually lay down together naked, with a single goatskin pulled over them; and Daphnis might easily have made a woman of Chloe, but for what Lycaenion had told him. Even so he was naturally afraid that reason might one day be overcome, so he did not allow Chloe to be naked very often. This surprised Chloe, but she was too shy to ask why it was.

During this summer Chloe had a great many suitors, and many people came from far and wide, and came repeatedly, to ask Dryas for her hand. Some brought presents with them, and the rest promised large marriage gifts. So Nape's hopes rose high, and her advice was that they should give Chloe in marriage and not keep a girl of her age at home any longer, who was liable at any moment to make a man of some shepherd or other, while she was out grazing, in return for a few apples or roses. Instead, they should set her up as mistress of her own house, make a lot of money themselves and keep it for their own rightful heir – since a son had been born to them not long before.

As for Dryas, he was sometimes charmed by the promises that were being made (for they were all offering larger marriage-gifts than might have been expected for a shepherd-girl), but at other times he thought that she was too good to marry a peasant, and that if he ever found her real parents she would make him and Nape very rich. So he kept postponing his decision and letting the thing drag on from day to day; and in the meantime he had the satisfaction of receiving a considerable number of presents.

When Chloe heard about it she was very unhappy; but for a long time she concealed the facts from Daphnis, because she did not want to make him unhappy too. When, however, he kept on questioning her and begging for an answer, and was more unhappy at not knowing the truth than he was likely to be if he knew it, she told him everything – how several rich men wanted to marry her, how Nape was arguing that she should be married off quickly, and how Dryas had not refused outright but had merely put off his decision until the vintage.

This news made Daphnis almost frantic. He sat down and burst into tears, saying that he would die if Chloe stopped grazing her flock with him – and he would not be the only one, for the sheep would die too if they lost a shepherdess like her.

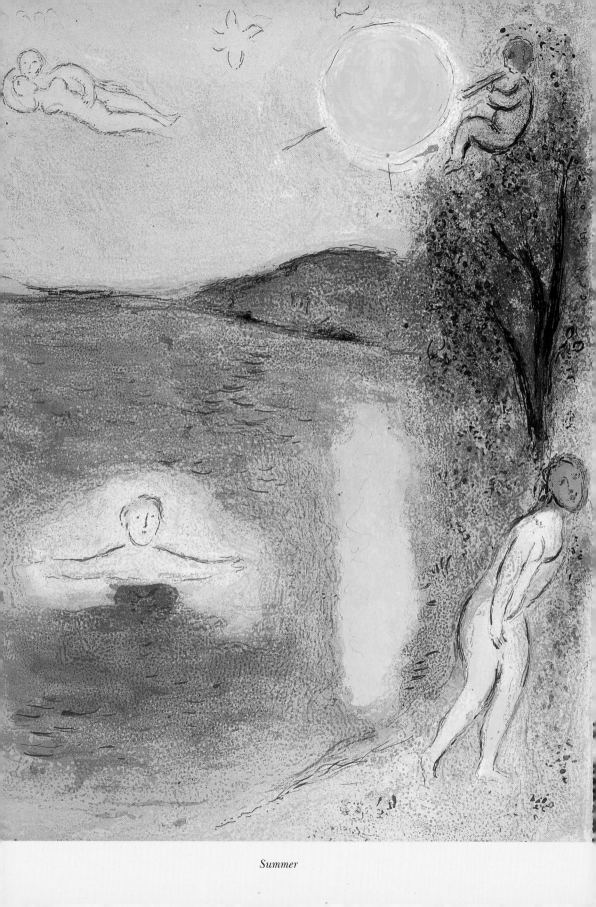

Summer

Then he recovered and began to cheer up. He made up his mind to speak to her father, started regarding himself as one of the suitors, and felt confident that he could easily beat the others. One thing worried him: Lamon was not a rich man. This was the only consideration that tended to make his hopes rather slender. Even so he thought he had better ask for her hand, and Chloe thought so too.

He did not dare to say anything to Lamon, but he plucked up enough courage to tell Myrtale of his love and talk about getting married. That night she passed it on to Lamon; but he was stubbornly opposed to the idea and upbraided her for proposing a mere shepherd's daughter as a wife for a boy who, as the tokens showed, was destined for great things, and who, if he found his relations, would not only give his foster-parents their freedom but would also make them the owners of a large estate.

Knowing that Daphnis was in love, Myrtale was afraid he might actually commit suicide if he lost all hope of marrying Chloe; so she gave him a different reason for Lamon's opposition: 'Son,' she said, 'we're poor, and want a daughter-in-law who'll bring money in rather than ask money from us. But they're rich and want a rich son-in-law. So come now, you talk to Chloe, and get her to persuade her father to give his consent without asking much in the way of marriage-gifts. For I'm sure she's in love with you too, and would rather sleep with a poor man who's good-looking than a rich man who looks like a monkey.'

Never imagining that Dryas would agree to this proposal so long as he had any richer suitors, Myrtale thought she had produced a good excuse for getting out of the marriage. But Daphnis, though he could find no fault with her argument, was so disappointed that he did what impoverished lovers usually do – burst into tears. Then he asked the Nymphs to help him and that night, while he was asleep, they appeared to him looking exactly the same as before. Again it was the eldest one who spoke.

'Chloe's marriage,' she said, 'is the business of another god, but we'll provide you with a present that will win Dryas over. The yacht belonging to the young men from Methymna, the yacht that your goats set adrift by eating the withy, was blown far away from land that day, but during the night a wind blowing off the sea made the water very rough, and the yacht was cast ashore on the rocks of the cape. So it and a great deal of its cargo were destroyed, but a purse containing three thousand drachmas was thrown up by the waves and is lying covered with seaweed beside a dead dolphin – as a result of which no one walking that way has gone anywhere near it, but everyone runs past to get away from the stench of the rotting corpse. But you go right up to it, and when you've got there pick up the purse, and when you've picked it up give it to Dryas. It's enough for you at present not to seem poor; but the time will come when you will actually be rich.'

With these words the Nymphs and Night departed simultaneously. Now that it was day, Daphnis jumped up in very good spirits and began with a great deal of whistling to drive his goats to pasture. Then after kissing Chloe and paying homage to the Nymphs he went down to the sea, as if he wanted to have a splash in it, and started walking along the sand at the point where the waves broke, looking for the three thousand drachmas. Apparently he was not going to have much trouble, for the foul smell of the dolphin, which had been thrown ashore and was slimy with decay, suddenly came to meet him; so following his nose he went straight up to the dolphin, removed the seaweed and found the purse full of money. He picked it up and put it in his knapsack, but before he went away he uttered a shout of praise to the Nymphs and to the sea itself; for though he was a goatherd, he now thought the sea even more delightful than the land – since it was the sea that was helping him to marry Chloe.

Now that he was in possession of the three thousand drachmas, he hesitated no longer, but feeling as if he were not merely the richest peasant in the district but the richest man in the world he at once went to Chloe, told her his dream, showed her the purse, and asked her to look after the flocks until he got back. Then he went bustling off in a tremendous hurry to see Dryas. He found him with Nape threshing corn, and with great self-confidence made his proposal of marriage:

'Please give me Chloe to be my wife. I'm very good at playing the Pan-pipe and pruning vines and planting trees. And I know how to plough a field and winnow grain in the wind. And Chloe can tell you how good I am at looking after a flock. I had fifty she-goats when I took over, and now I've double that number. I've also reared some fine big he-goats – we used to mate our she-goats with other people's he-goats before. What's more, I'm young, and I'm an excellent neighbour of yours. And I was nursed by a she-goat, just as Chloe was by a ewe. I've got all these advantages over the others, and I'm not going to be at a disadvantage when it comes to marriage-gifts either. For they'll only give you a few goats and sheep, and a couple of mangy oxen, and some corn that's not even fit to feed hens on, but I'll give you – here you are – three thousand drachmas! Only don't let anyone know about it, not even my father Lamon.'

As he handed over the money, he flung his arms round them and kissed them.

At the unexpected sight of so much money they immediately promised to give him Chloe, and undertook to talk Lamon round. So while Nape stayed with Daphnis, driving the oxen round and grinding the ears of corn in the threshing-machine, Dryas stored away the purse in the place where the tokens were kept and rushed off in a great hurry to visit Lamon and Myrtale and do a most unusual thing – ask them for their son's hand in marriage.

The Dead Dolphin and the Three Thousand Drachmas

He found them measuring the barley that had just been win-
nowed, and feeling depressed because it amounted to almost
less than the seed that had been sown. He tried to console them
about this by saying that there had been the same complaint
everywhere, and then asked for Daphnis as a husband for
Chloe. He said that though other people were making big offers
for her, he was not going to accept any of them. On the contrary
he intended to give her a dowry out of his own pocket, for
Daphnis and Chloe had been brought up together, and while
grazing their flocks had grown too fond of one another to be eas-
ily parted; and now they were old enough to sleep together. He
said this and a good deal more; for he was speaking for a prize
of three thousand drachmas which would be his if he carried
his point.

Lamon could no longer plead his poverty as an excuse, since
Dryas and Nape themselves were not being proud about it; nor
could he make an excuse of Daphnis's age, for he was already a
young man. Even so he did not come out with what he really
meant – that Daphnis was too good for such a marriage – but
after a short silence replied as follows: 'You're quite right to put
your neighbours before strangers, and not think wealth
superior to honest poverty. May Pan and the Nymphs bless you
for it! And I'm very much in favour of this marriage myself, for
I'd be mad not to think it a great advantage to gain the
friendship of your family, now that I'm an old man and need
extra hands to get the work done. Besides, Chloe's a girl who's
very much sought after, pretty and fresh and excellent in every
way. But being a slave I can't make my own decisions about any
member of my family. My master will have to be told of it and
give his consent. So look here, let's put off the wedding until the
autumn, for then he'll be here, according to reports that have
been reaching us from town. Then they can be man and wife,
but in the meantime they must love one another like brother and

sister. And there's one thing I want you to know, Dryas: the lad that you're taking all this trouble about is a cut above us.'

Having said this he kissed him and offered him a drink, for by this time it was high noon. Then after treating him with every possible kindness he saw him some of the way home.

The significance of Lamon's last remark had not been lost on Dryas, and as he walked along by himself he began to wonder who Daphnis really was.

'He was suckled by a she-goat, as if Providence was looking after him. And he's very good-looking, not at all like that snub-nosed old man and that bald wife of his. And he managed to lay his hands on three thousand drachmas, though you wouldn't expect a goatherd to have three thousand of anything – even wild pears. I wonder if someone exposed him, like Chloe? I wonder if Lamon found him, as I did her? And I wonder if there were any tokens beside him, like the ones that I found? If so, then by great Pan and the dear Nymphs, perhaps when he's found his own relations he'll find out something about the mystery surrounding Chloe!'

Such were his thoughts and dreams all the way back to the threshing-floor. When he got there and found Daphnis all agog for news, he put new life into him by addressing him as son-in-law, promised to celebrate the wedding in the autumn, and gave him his word that Chloe should belong to no man but Daphnis.

So quicker than thought, without having anything to drink or eat, he ran back to Chloe, whom he found milking and making cheese, and told her the good news about their marriage. Then he kissed her without any attempt at concealment, since he now regarded her as his wife, and helped her with the work. He milked the milk into the pails, set the cheeses in flat baskets to dry, and placed the lambs and kids underneath their mothers to feed. When these jobs had been done, they washed, ate, drank, and began to walk round looking for ripe fruit.

The season had been a good one and there was a great deal of fruit about – plenty of pears, both wild and cultivated, and plenty of apples. Some of the apples had fallen down, but the rest were still on the trees. Those on the ground smelled sweeter, those on the branches looked fresher: the former smelt like wine, the latter shone like gold.

One apple-tree had been stripped of all its fruit and leaves. Every branch was bare, except that right at the top of the very topmost branches dangled a single apple. It was a fine big apple and had more scent by itself than all the rest put together. The man who had been stripping the tree had either been afraid to climb so high or else been too careless to get it down. And perhaps this beautiful apple was being kept in reserve for some shepherd who was in love.

When Daphnis saw this apple he determined to climb up and pick it, and ignored Chloe's efforts to prevent him. So, angry at being ignored, she went off towards the flocks. But Daphnis climbed rapidly up the tree and reached the apple; and when he had picked it and taken it to Chloe as a present, he addressed her, angry as she was, like this: 'Dear girl, this apple was born at a beautiful time of year and nursed by a beautiful tree. It was ripened by the sun and protected by fortune. And so long as I had eyes, I wasn't going to leave it to fall on to the ground and be trampled underfoot by grazing cattle, or poisoned by some gliding snake, or wasted away by time as it lay there, while people merely stared at it and praised it. This was the prize that Aphrodite accepted for her beauty, and this is the prize of victory that I give you. And she had the same sort of judge as you have, for he was a shepherd and I'm a goatherd.'

Having said this, he placed the apple in her bosom, and as he came close to her she kissed him. So Daphnis had no regrets for having dared to climb so high, since the kiss that he got was better than any apple, even a golden one.

Fourth Book

ONE of Lamon's fellow-slaves now arrived from Mytilene with the news that their master was coming down just before the vintage to find out if the raid by the Methymneans had done any damage to the estate. So as summer was already departing and autumn was approaching, Lamon began to prepare for his master's reception, and tried to make everything a pleasure to look at. He cleaned out the springs to ensure that the water was pure, carted the dung out of the farmyard lest the smell should cause annoyance, and tidied up the garden so that it could be seen in all its beauty.

This garden was indeed a very beautiful place even by comparison with a royal garden. It was two hundred yards long, lay on high ground, and was about a hundred yards wide. It was not unlike a long field. It contained all sorts of trees, apple-trees, myrtles, pear-trees, pomegranate-trees, fig-trees and olives. On one side there was a tall vine that grew over the apple-trees and pear-trees; its grapes were turning dark, as if ripening in competition with the apples and the pears. So much for the cultivated trees; but there were also cypresses and laurels and plane-trees and pines. All these were overgrown, not by a vine, but by ivy; and the clusters of ivy-berries, which were big and beginning to turn black, looked exactly like bunches of grapes.

The fruit-trees were in the middle, as if for protection, and the other trees stood round them, as if to wall them in; but these in their turn were encircled by a narrow fence. Each tree grew separate and distinct from all its neighbours, and there were spaces between trunk and trunk. But overhead the branches met each other and interlaced their foliage; and though it had happened naturally this too gave the impression of having been

done on purpose. There were also flowerbeds, in which some of the flowers were wild and some were cultivated. The cultivated ones were roses, hyacinths and lilies: the wild ones were violets, narcissi and pimpernels. And there was shade in summer, and flowers in springtime, and fruit in autumn, and delight all the year round.

From that point there was a fine view of the plain, where you could see people grazing their flocks, and a fine view of the sea, where you could watch people sailing past; and this too contributed to the charm of the garden. In the very middle of the length and breadth of the garden were a temple and an altar sacred to Dionysus. The altar was surrounded with ivy and the temple with vine-shoots. Inside the temple were some paintings on subjects connected with Dionysus – Semele giving birth to him, Ariadne asleep, Lycurgus in chains, Pentheus being torn to pieces. There were also pictures of Indians being conquered and Tyrrhenians being turned into dolphins. Everywhere Satyrs were treading down grapes and everywhere Bacchants were dancing. Nor was Pan forgotten, for he was there too, sitting on a rock and playing his pipe as if to provide a musical accompaniment for both the treaders and the dancers.

Such was the garden that Lamon now began to put in order, cutting away the dry wood and tying up the vine-shoots. He also placed a wreath on Dionysus, and watered the flowers. There was one particular spring which Daphnis had found for this purpose; and though it was kept for watering the flowers, it was named after him and was known as Daphnis's Spring.

Lamon also urged Daphnis to fatten up the goats as much as he possibly could, saying that their master was sure to look at them, as he had not been there for so long. Daphnis felt quite confident that he would be congratulated on them, for he had doubled their number since he took them over, not one had been carried off by a wolf, and they were fatter than the sheep.

So off he went in a very friendly mood, while Daphnis in an agony of suspense grazed his flock with Chloe. She too was extremely frightened. A lad who was only used to seeing such things as goats, and a hillside, and peasants, and Chloe, was about to have his first sight of a master who had been merely a name to him before. So she was putting herself in Daphnis's place and wondering how he was going to face his master; and she was very uneasy in her mind about the marriage, for fear they should find that it had all been a dream. As a result, they kissed each other incessantly and embraced so tightly that they seemed to have grown together. And their kisses were apprehensive and their embraces were gloomy, as if their dreaded master was already there and they were trying not to be seen.

They were also upset by the following incident. Among those who had been asking Dryas for Chloe's hand was a very aggressive cowherd called Lampis. He had already given a great many presents in his efforts to bring about the marriage, and when he heard that Daphnis was going to marry her if their master gave his consent, he tried to think of a plan for setting their master against them. Knowing that he was very fond of the garden, Lampis decided to do his best to spoil and disfigure it. If he cut down the trees he was liable to be caught because of the noise; so he applied himself to the task of destroying the flowers. He waited until it was dark, climbed over the fence, and then pulled some of them up, broke others off, and trampled the rest underfoot just as a pig might have done.

He then got away without being seen. Next day Lamon went into the garden intending to water the flowers from the spring; but when he saw that the whole place had been laid waste – a thing that no thief, but only an enemy would have done – he immediately started tearing his shirt to ribbons and yelling at the top of his voice and calling on the gods. The result was that Myr-

Wishing, however, to make his master even more in favour of the marriage, he started giving them every possible care and attention. He drove them to pasture early in the morning and brought them back late at night. He led them to water twice a day and sought out the best places to graze them in. He also provided himself with some new milk-bowls, plenty of milk-pails, and some larger baskets for cheese. And such was his enthusiasm that he actually started oiling the goats' horns and combing their hair, until they looked like a sacred flock belonging to Pan. Chloe shared all the trouble that he took with them, and neglected her sheep in order to concentrate on the goats; which made Daphnis think that they owed their beauty to her.

While they were thus engaged, a second messenger arrived from town who told them to strip the vines as quickly as possible, and said that he was going to stay there until they had turned the grapes into must, and would then return to the city and fetch their master, when the vintage was already under way. So they gave this messenger (who was called Eudromus or Runwell, since running was his job) a very hearty welcome and immediately began to strip the vines, carrying the grapes into the wine-presses, drawing off the must into the wine-jars, and setting aside the bunches with the finest bloom on them, still attached to the vine-shoots, so that even the visitors from the city might have some idea what the vintage was like and derive some pleasure from it.

When Eudromus was just about to go bustling off to town, Daphnis gave him, along with several other presents, samples of everything that a herd of goats could supply, some firm cheeses, a kid that had been born late in the year, and a shaggy white goatskin so that he would have something extra to put on for running messages during the winter. Eudromus was delighted. He kissed Daphnis and promised that he would say a good word for him to their master.

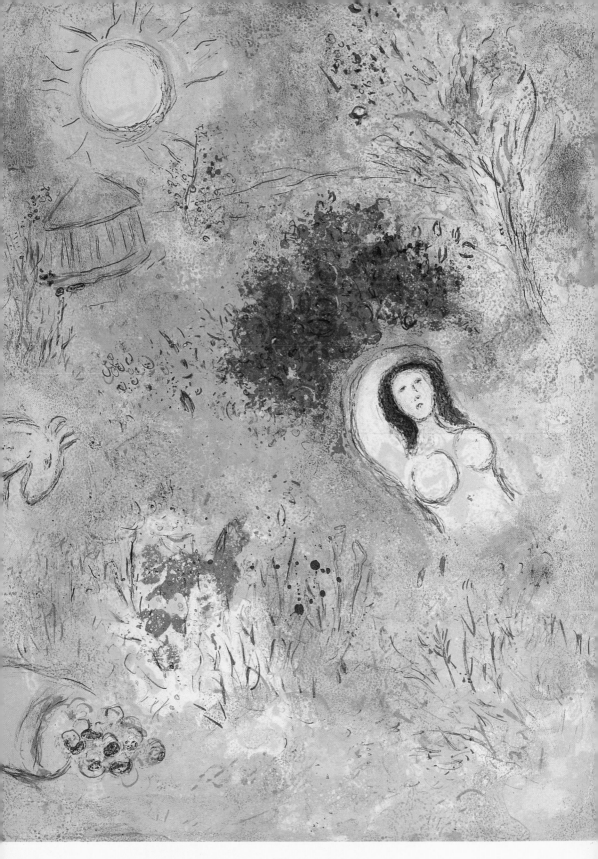

Chloe

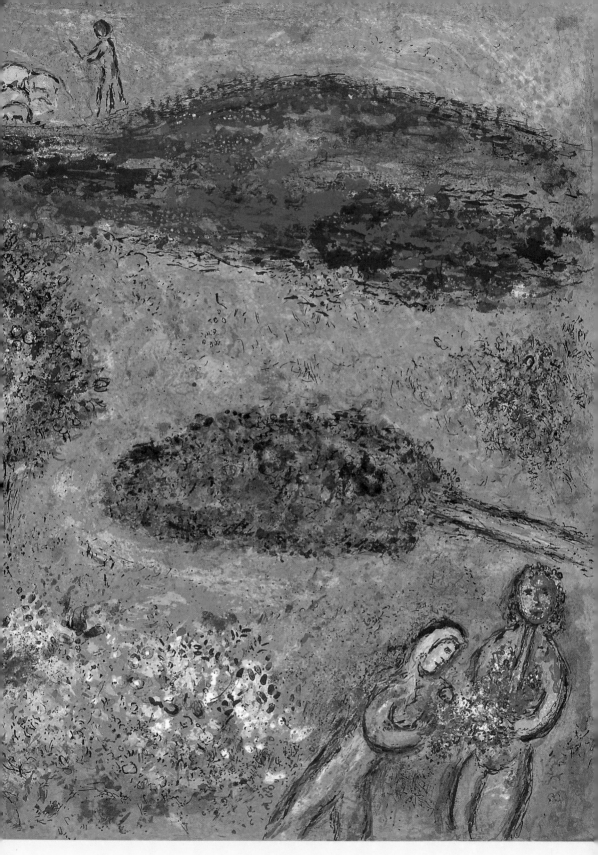

A Royal Garden

tale dropped what she was doing and ran out too, and Daphnis left the goats to look after themselves and ran back. When they saw what had happened they started yelling too, and then burst into tears.

Well, there was no point in grieving about the flowers; but they were crying because they were afraid of what their master would say, and even a stranger would have cried if he had been there, for the place was completely spoilt and all the ground was now a mass of mud. Yet the few plants that had survived the outrage were still trying to flower, still shining away and looking beautiful although they had been thrown down; and the bees still hovered over them, buzzing continuously and without a pause as if they were mourning for them.

Lamon was so upset that he started talking like this:

'Oh, the poor roses – look how they've been broken down! Oh, the poor violets – look how they've been trodden on! Oh, the poor hyacinths and narcissi – some wicked man has pulled them up! Spring will come but they will never bud, summer will come but they will never flower, autumn will come but they will never make a crown for anyone's head. Didn't even you feel sorry for these wretched flowers, Lord Dionysus? You used to live beside them and look at them, and I've often crowned you with them in happier days. Oh, how can I possibly show my master the garden now? What will he do when he sees it? He'll have a certain old fellow hanged from a pine, like Marsyas – and perhaps he'll hang Daphnis too, thinking that the goats have done it.'

At the thought of this some even hotter tears were shed, and they were mourning now not for the flowers but for themselves. Chloe mourned too at the suggestion that Daphnis was going to be hanged and prayed that their master would never come, and drained the cup of misery to the dregs, as though she could already see Daphnis being whipped.

When night was already falling, Eudromus appeared with the news that their master would be there in three days' time, but that his son was coming first and would arrive next day. So they began to talk the situation over and invited Eudromus to join the discussion. Eudromus, who felt kindly disposed towards Daphnis, advised them to make a clean breast of it to their young master beforehand, and promised to do what he could to help them, saying that he had some influence with the young man, as they were foster-brothers; so next day they acted accordingly.

Astylus arrived on horse-back with a hanger-on of his, also on horse-back. Astylus was just beginning to grow a beard, whereas Gnathon (for that is what the other man was called) had long been shaving one off. Lamon knelt down with Myrtale and Daphnis at Astylus's feet, and begged him to take pity on a poor old man who had done no harm, and protect him from his father's anger. At the same time Lamon told him the whole story.

Astylus was touched by this appeal, and after visiting the garden and seeing the damage that had been done to the flowers he promised that he would intercede with his father and put the blame on the horses, saying that they had been tethered there, had stampeded and got loose, and had then broken off some of the flowers, trampled down others, and rooted up the rest.

On the strength of this Lamon and Myrtale called down every blessing on Astylus's head, and Daphnis brought him some presents – kids, cheeses, birds with their broods, grapes on their vine-shoots and apples on their boughs. The presents also included some Lesbian wine with a very fine bouquet – the finest wine you could drink.

So Astylus made some appreciative remarks about the presents, and turned his attention to hunting hares; for he was a rich young man who had always lived for pleasure and had come down into the country to find a new way of amusing himself. But Gnathon, a fellow who had only learnt to eat, to drink until he

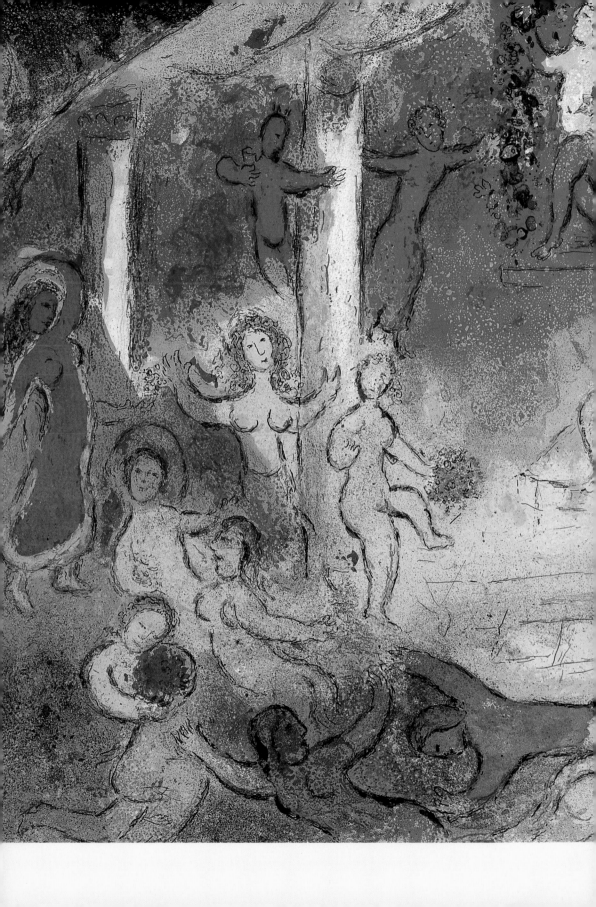

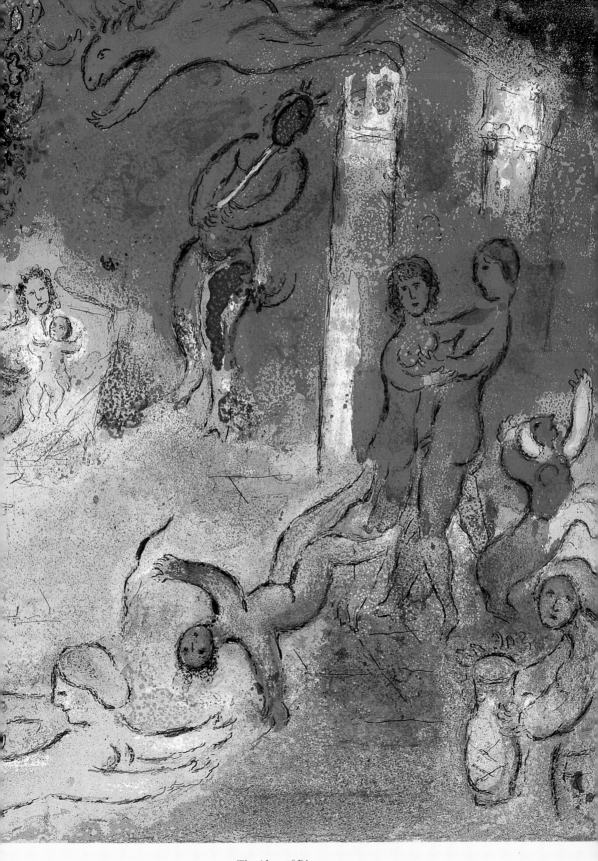

The Altar of Dionysus

was drunk, and when he was drunk to copulate, who was nothing but a mouth and a stomach and what lies under the stomach, had not failed to observe Daphnis closely when he brought the presents. Having homosexual tastes, he found Daphnis more attractive than anything he had seen in the town, so he decided to make advances, thinking that a goatherd should be quite easy to seduce. With this object in view, instead of joining Astylus on the hunting-field he went down to the place where Daphnis was grazing his flock and began to stare, ostensibly at the goats, but actually at Daphnis. Then to flatter him he started praising the goats and begging him to play some goatherd's tune on his Panpipe. He also said that he had an immense amount of influence and would make Daphnis a free man.

Then he asked him to present his backside, as a she-goat would to a he-goat. When Daphnis finally realized what he meant, he replied that it was quite all right for a he-goat to do that sort of thing to a she-goat, but no one had ever heard of a he-goat doing it to another he-goat, or a ram to another ram, or a cock to another cock. So Gnathon actually tried to rape him; but Daphnis pushed him away – he was almost too drunk to stand – and knocked him down. He then scampered off like a puppy, leaving Gnathon stretched on the ground; and what he wanted now was not a boy, but a man – to carry him home.

After that Daphnis would not let Gnathon come anywhere near him, but grazed his flock first in one place and then in another, so as to avoid him and keep Chloe safe. Nor did Gnathon interfere with him again, once he learnt that Daphnis was strong as well as beautiful. But he started looking for an opportunity to talk to Astylus about him, in the hope of getting Daphnis as a present, since his young master was always prepared to be generous.

He could not do it then, for Dionysophanes was arriving with Cleariste, and the place became a chaos of baggage-animals and

domestic servants, male and female. But afterwards he started preparing a long speech about his love.

Dionysophanes was already going grey, but he was tall and handsome and a match for any youngster. He had few equals in wealth and none in worth. On the first day after his arrival he sacrificed to the gods that preside over the country, Demeter and Dionysus and Pan and the Nymphs, and set up a bowl of wine to be shared by all present. On the following days he inspected Lamon's farm. When he saw the fields all ploughed, the vines putting out new shoots, and the garden looking beautiful (for Astylus had taken the blame for the state of the flowers), he was extremely pleased. He congratulated Lamon and promised to give him his freedom.

After that he walked down to the goat-pasture to see the goats and the boy who grazed them. So Chloe ran away into the wood, feeling shy and frightened at the sight of so many people; but Daphnis stood there with a shaggy goatskin tied round his waist, a newly-stitched knapsack hanging from his shoulders, and both his hands full – for in one of them he held some fresh cheeses and in the other some unweaned kids. If it is true that Apollo once worked for Laomedon as a cowherd, he must have looked exactly as Daphnis looked then.

Daphnis said nothing, but blushed deeply and bowed low and held out his presents, while Lamon said:

'Here's the boy that grazes your goats, master. You gave me fifty she-goats and two he-goats to look after, and he's turned them into a hundred she-goats and ten he-goats for you. Do you see how sleek they are, and what thick coats they have, and how none of their horns are broken? What's more, he's given them an ear for music. At any rate they do everything to the sound of a Pan-pipe.'

Cleariste was there and heard what was being said; and she wanted to find out for herself whether Lamon had spoken the

truth. So she told Daphnis to pipe to the goats in his usual way, and promised that when he had done so she would give him a shirt and a cloak and a pair of sandals.

Daphnis made them sit down like the audience at a theatre, and standing under the oak he produced his Pan-pipe from his knapsack and began by blowing on it softly – and the goats raised their heads and stood still. Then he blew the grazing tune – and the goats put their heads down and started to graze. He played another tune, very sweet and clear – and they all lay down. He also piped a shrill sort of tune – and they ran away into the wood as though a wolf was approaching. A little later he sounded a recall – and they came running out of the wood and collected round his feet. You would not have found even human slaves being so obedient to their master's orders.

They were all amazed, especially Cleariste, who swore to give him the presents she had promised, saying that he was not only a fine goatherd but a fine musician as well. Then they returned to the cottage and set about having lunch; and they sent Daphnis some of the food from their own table.

So he shared it with Chloe and enjoyed his first taste of town cooking, feeling confident that he would succeed in getting his master's consent to the marriage. But Gnathon, whose desires had been inflamed even more by what had happened at the goat-pasture and who thought that life would not be worth living if he could not have Daphnis, watched for a moment when Astylus was walking about in the garden, and after taking him into the temple of Dionysus started kissing his feet and hands. When Astylus asked why he was doing it, and told him to speak out, and swore that he would help him, Gnathon said:

'Your poor Gnathon's in despair! I who till now loved nothing but your table, who used to swear in the past that there was nothing more beautiful than an old wine, who used to say that I found your chefs more attractive than the young lads of

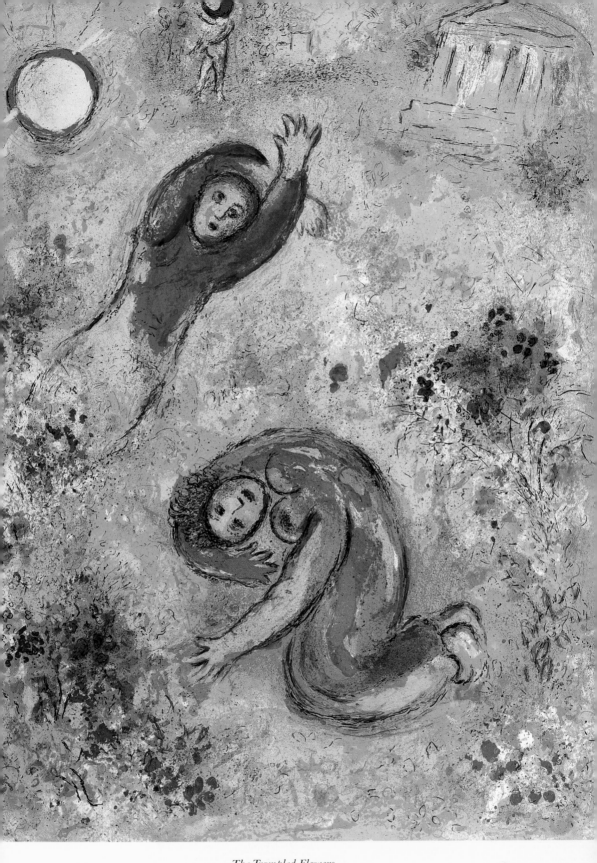

The Trampled Flowers

Mytilene, can now see no beauty in anything but Daphnis. I don't enjoy expensive food, although there's so much being prepared every day, meat and fish and honey-cakes – but I'd gladly become a goat and eat grass and leaves, listening to Daphnis's pipe and being grazed by him. So please come to your poor Gnathon's rescue and conquer unconquerable love. If not, I swear to you by my favourite god, Dionysus, that I'll take a dagger, and after filling my stomach with food I'll kill myself at Daphnis's door. And you'll never call me your tiny little Gnathon any more, as you always used to do when you were joking.'

Astylus was a generous young man with some experience of the pangs of love, and he could not resist Gnathon when he burst into tears and started kissing his feet again. So he promised to ask his father's permission to take Daphnis to the city as a servant for him and as company for Gnathon. Then, to cheer Gnathon up, he asked him with a smile if he was not ashamed to make so much fuss about the son of a man like Lamon. Did he really want to have anything to do with a boy who grazed goats? As he said this he made a gesture of disgust at the way he-goats smelled.

But Gnathon, who had picked up all the stories that had anything to do with love while drinking in low company, produced an apt defence both of himself and of Daphnis:

'No lover worries about things like that, master. Whatever sort of body he finds beauty in, he's caught just the same. That's why people have actually fallen in love with trees and rivers and wild beasts – though who could help feeling sorry for a lover that had to go in fear of his beloved? In my case, though Daphnis is only a slave he's got the sort of beauty that any free man might be proud to possess. Don't you see what hair he has – just like a hyacinth? Don't you see how his eyes shine out from beneath his brows – like jewels in a golden setting? Look at his rosy complexion, and his mouth – full of teeth whiter than

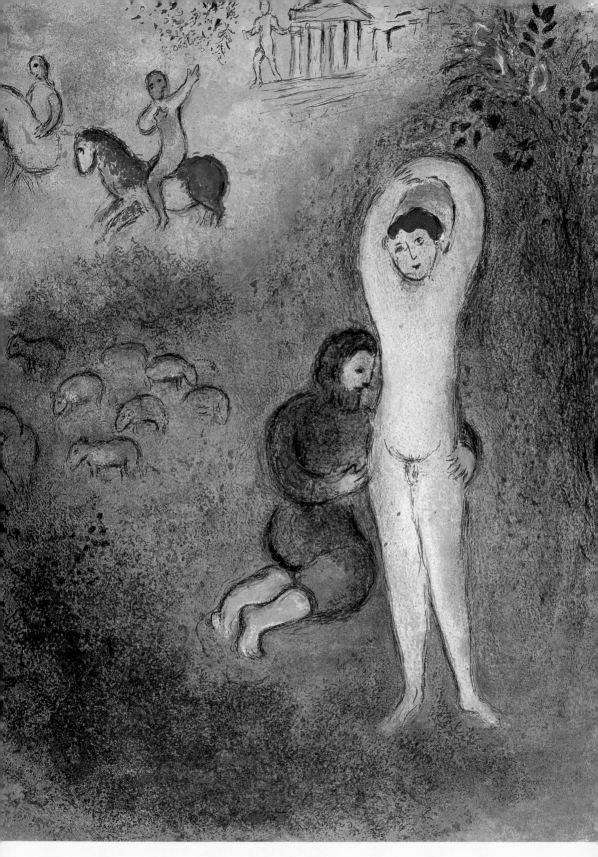

Daphnis and Gnathon

ivory! What lover could help longing to take sweet kisses from a mouth like that? And if I've fallen in love with a herdsman, I've only followed the example of the gods. Anchises was a cowherd, and he was the darling of Aphrodite. Branchus used to graze goats, and he was loved by Apollo. Ganymede was a shepherd, and he was carried off by the king of the universe. Don't let's look down on a boy whom we've seen even goats obeying, as if they were in love with him. Instead, let's be grateful to the eagles of Zeus for allowing such beauty to remain on the earth.'

Astylus laughed merrily at this last remark in particular, and said that Love made people very good at special pleading; after which he started looking for an opportunity to talk to his father about Daphnis.

But Eudromus had overheard all that was said and partly because he liked Daphnis and thought him a good lad, and partly because he hated the idea of beauty like his being subjected to Gnathon's drunken violence, he at once told Daphnis and Lamon all about it. Daphnis was appalled, and decided that he must either take the risk of running away with Chloe or else get her to die with him. But Lamon called Myrtale outside the house and said to her:

'Wife, we're finished. The time has come for secrets to be revealed. It'll mean losing my goats and everything else. But by Pan and the Nymphs, even if it means being left as poor as an ox in its stall, as the saying is, I refuse to keep quiet about Daphnis's birth. I'll say that I found him exposed, and I'll describe how he was being suckled, and I'll show what I found with him. That disgusting creature Gnathon has got to learn what sort of person he is and what sort of person he's in love with. Just get the tokens ready for me.'

Having agreed on this plan they went indoors again. But Astylus waited until his father was at leisure and then sidled up to him and asked permission to take Daphnis back to the city, say-

ing that he was a handsome lad who was too good for the country and could soon be taught town ways by Gnathon. His father gladly gave his consent, and having sent for Lamon and Myrtale told them the good news that Daphnis was to wait on Astylus in future, instead of waiting on a lot of male and female goats; and he promised to give them two goatherds in exchange for Daphnis.

All the other slaves had already come crowding round, delighted at the prospect of having such a handsome fellow-slave, when Lamon asked leave to speak and began as follows:

'Master, hear the truth from an old man. I swear by Pan and the Nymphs that I'll tell no lies. I'm not Daphnis's father, nor has Myrtale ever been lucky enough to become a mother. His real parents exposed him because they had enough children already, and after he'd been exposed I found him being suckled by one of my she-goats. So when she died I buried her just outside the garden, because I loved her for having mothered him. Also I found some tokens that had been left with him – I admit I did, master, and I've kept them ever since, because they show that his rank is superior to ours. So while I've no objection to his waiting on Astylus – for he'll make a fine servant for a fine good master – I can't stand by and see him become the victim of Gnathon's drunken violence – for Gnathon is intent on getting him to Mytilene, so that he can make a woman of him.'

Having said this Lamon stopped speaking and burst into tears. But when Gnathon tried to brazen it out and threatened to whip him, Dionysophanes, who was amazed at what Lamon had said, frowned sternly at Gnathon and told him to be quiet. Then he started questioning Lamon again and urging him to tell the truth instead of inventing fairy-stories in order to keep Daphnis living at home as his son. But Lamon remained obstinate, and swore by all the gods that he *was* telling the truth, and said they could examine him under torture, if they liked, to see

if he was lying. So with Cleariste sitting in judgement on the case, Dionysophanes began to review the evidence as follows:

'Why should Lamon lie when he's going to get two goatherds instead of one? And how could a peasant invent such a story? Indeed, wasn't it incredible from the start that an old man like that and his vulgar wife should have such a handsome child?'

It seemed best to stop guessing and look at the tokens right away, to see if they suggested a noble or distinguished origin. Off went Myrtale to fetch them; for they were all stowed away in an old knapsack. When she had brought them, Dionysophanes looked at them first and seeing a little cloak dyed with genuine purple, a brooch of beaten gold and a dagger with an ivory hilt, he shouted out: 'Oh, Lord Zeus!' and told his wife to come and look. When she saw them, she too gave a loud cry.

'Dear Fates!' she exclaimed. 'Aren't these the things that we put out with our own son? When we sent Sophrone off, weren't these the fields that we told her to take him to? Yes indeed, dear husband, these are the very same things. The child is ours, Daphnis is your son and he's been grazing his own father's goats.'

While she was still speaking and Dionysophanes was kissing the tokens and weeping from excess of joy, Astylus, who had realized that Daphnis was his brother, flung off his cloak and started running down from the garden, wishing to be the first to give Daphnis a kiss. But when Daphnis saw him running along with a crowd of people and shouting 'Daphnis!' he thought he wanted to catch him and take him away; so he threw down his knapsack and his Pan-pipe and went dashing towards the sea, meaning to hurl himself off the top of the great cliff. And perhaps, paradoxically, he might have been lost because he was found, had not Astylus understood and shouted out again:

'Stop, Daphnis! Don't be frightened. I'm your brother and your parents are the people who've been your master and mis-

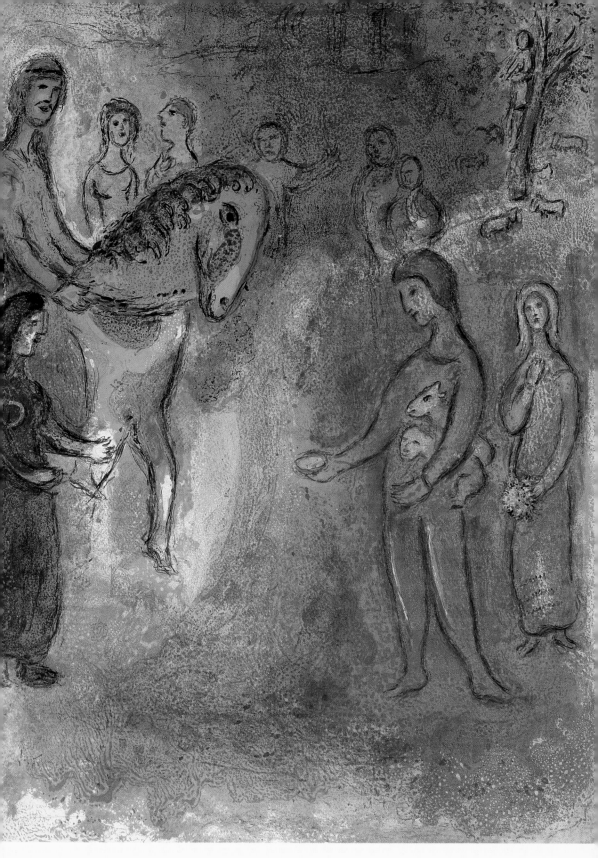

The Arrival of Dionysophanes

tress up to now. Lamon has just told us about the she-goat and shown us the tokens. So turn round and look – there they come, laughing and beaming with joy! But kiss me first – for I swear by the Nymphs I'm not lying.'

At this oath Daphnis finally consented to stop. He waited for Astylus to run up and kissed him when he arrived. While he was kissing him, the rest of the crowd came streaming to the spot – manservants, maidservants, his father himself and his mother with him. They all started embracing and kissing and weeping for joy; but Daphnis embraced his father and mother before any of the others, and as if he had known the truth for a long time he kept clasping them to his breast and was reluctant to leave their arms – which shows how quick we are to believe what our natural instincts tell us. For one moment he even forgot about Chloe.

He was taken back to the cottage and given expensive clothes. Then he sat down beside his real father and heard him speak as follows:

'My sons, I married quite young, and before long I had become, as I thought, a very lucky parent. For first a son was born to me, then a daughter, and then Astylus. I thought the family was now large enough, and when this child was born after all the others, I exposed him, and left these things with him not as tokens of his identity but as funeral offerings. But Fortune had other plans, for my elder son and my daughter died in the course of a single day from the same sort of illness, and you have been preserved for me by Providence so that we should have more than one son to support us in our old age. So don't hold it against me that I exposed you, Daphnis – for it was only most reluctantly that I decided to do so. And don't be annoyed, Astylus, that you'll be sharing my property instead of getting the whole of it – for to right-minded people there's no more precious possession than a brother. But love one another, and as far as money

134

is concerned you can regard even kings as your equals. For I shall leave you a great deal of land and a great many efficient slaves, and gold and silver and all the other things that rich men possess. Only I'm putting this estate on one side and giving it to Daphnis, together with Lamon and Myrtale and the goats that he himself has been grazing.'

While he was still speaking, Daphnis jumped up.

'Thank you for reminding me, father,' he said. 'I'll go and drive the goats to water, for I expect they're thirsty and are waiting impatiently for the sound of my pipe, while I'm sitting here.'

Everyone burst out laughing merrily to think that he still wanted to be a goatherd, when he had become a landowner. So someone else was sent to look after the goats, while Daphnis and his family performed a sacrifice to Zeus the Preserver and started making arrangements for a feast. To this feast everyone came except Gnathon, who was so frightened that he had taken refuge in the temple of Dionysus and was staying there day and night. The story soon reached everybody's ears that Dionysophanes had found a son and that Daphnis the goatherd had turned out to be one of the owners of the estate. So early next morning people started pouring in from all directions, to congratulate the boy and to bring his father presents. The first to arrive was Dryas, Chloe's foster-father.

Dionysophanes made them all stay and share his feast as well as sharing his joy. A great deal of wine had been got ready, a great deal of flour, water-fowl, sucking pigs, and various kinds of honey-cake; and a great many sacrifices were made to the local gods.

Then Daphnis collected all his pastoral possessions together and divided them out among the gods as thank-offerings. To Dionysus he offered his knapsack and his goatskin, to Pan his shepherd's staff and the milk-pails that he had made with his own hands. And so true is it that familiar objects have a greater

appeal than unfamiliar blessings, that he wept over each of these things as he parted from it. Nor did he offer up the milk-pails until he had once more milked into them, nor the goatskin until he had once more put it on, nor the Pan-pipe until he had once more played on it. He acutally kissed all these things, and talked to the she-goats and called the he-goats by name. Nor was that all, for he also had a drink from the spring because he had drunk there so often, and had done so in Chloe's company. He did not intend, however, to confess his love just yet, but was watching for a suitable opportunity.

While Daphnis was busy with his offerings, this is what was happening to Chloe. She was sitting in tears beside her sheep, and saying the kind of thing that was natural in the circum-stances:

'Daphnis has forgotten all about me! Now he has visions of marrying someone rich. Oh, why did I ask him to swear by the goats instead of by the Nymphs? He's deserted the goats, just as he's deserted Chloe. Even when he was making offerings to the Nymphs and Pan he had no desire to see Chloe. Perhaps he's found that some of his mother's maids are prettier than I am. Goodbye to him, then – but I'll not live without him.'

While she was talking like this and having thoughts like these, Lampis the cowherd appeared with a gang of farm-hands and kidnapped her – on the assumption that Daphnis would not marry her now, and that Dryas would be content to have Lampis as a son-in-law. So she was carried off wailing piteously; but someone who saw the incident reported it to Nape, and she told Dryas and Dryas told Daphnis. Daphnis nearly went out of his mind; he did not dare to speak to his father – and yet he could not bear it. He rushed into the garden and began to express his misery in these words:

'Oh, hateful discovery! How much better off I was grazing goats! How much happier I was when I was a slave! In those days

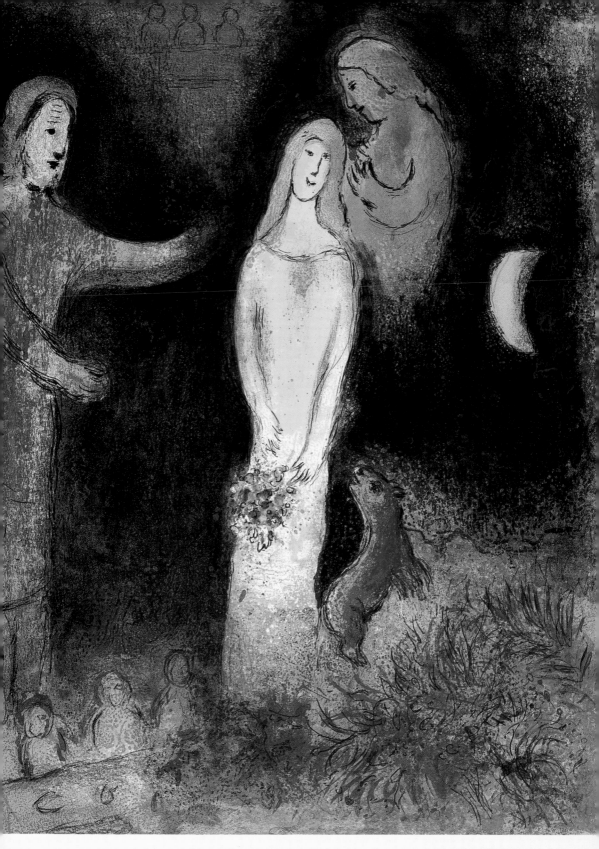

Cleariste Dresses Chloe and Combs Her Hair

I used to see Chloe. In those days I used to kiss her. But now
Lampis has gone off with her and tonight he'll sleep with her.
And here I am, drinking and living in luxury – as if the oath I
swore by Pan and the goats meant nothing at all.'

Gnathon, who was hiding in the garden, heard him talking
like this and thought his chance had come to earn Daphnis's for-
giveness. So he got some of Astylus's young men to join him, and
hurried after Dryas, whom he ordered to show them the way to
Lampis's cottage. He then went dashing off at a great speed,
caught Lampis just as he was taking Chloe indoors, rescued her
and gave the fellow a good thrashing. He wanted to tie up Lam-
pis himself and lead him off in triumph like some prisoner-of-
war; but he ran away just in time. Having accomplished this
great exploit, Gnathon returned as night was falling. Dionyso-
phanes had gone to bed, but Daphnis could not sleep and was
still in the garden, crying. Gnathon led Chloe to him, and as he
handed her over related the whole story. He begged Daphnis to
stop being angry with him and accept him as a servant who was
not without his uses; and he begged him not to banish him from
his table, which would result in his dying of hunger. When
Daphnis saw Chloe, and held Chloe in his arms, he forgave
Gnathon for everything in view of this good deed, and began to
apologize to Chloe for his neglect.

After talking the matter over they decided that Daphnis
should say nothing about the marriage and should keep quiet
about Chloe, except for telling his mother that he was in love.
But Dryas did not agree; he wanted Daphnis to tell his father,
and promised that he himself would talk Dionysophanes round.
So next day he put the tokens in his knapsack and went up to
Dionysophanes and Cleariste when they were sitting in the gar-
den. Astylus was there too, and so was Daphnis himself. As soon
as there was a pause in the conversation Dryas began to speak:
'Like Lamon I'm compelled to say something that I've kept a

secret up to now. Chloe here is not my daughter, and I had no hand in nursing her. She's someone else's daughter, and she was suckled by a ewe as she lay in the cave of the Nymphs. I saw it with my own eyes, and it was a most astonishing sight, and because I was so astonished I brought her up. One piece of evidence for this is her beauty – for she's not at all like us. As further evidence, there are the tokens that I found with her – they're far too valuable to belong to an ordinary shepherd. Please look at them, and try to find out who the girl's relations are – just in case she turns out to be a suitable match for Daphnis.'

Dryas had not thrown out his last remark at random, nor was its significance lost on Dionysophanes. He glanced at Daphnis and seeing that he was pale and that tears were stealing down his cheeks, he immediately recognized the signs of love. So feeling more anxious now about his own son than about someone else's daughter, he started to investigate every detail of Dryas's story. Then after seeing the tokens that Dryas had brought, the gilded sandals, the anklets, and the girdle, he called Chloe to him and told her to cheer up, saying that she had got a husband already and would soon be finding both her father and her mother. So Cleariste took charge of her and dressed her for the part of Daphnis's future wife, while Dionysophanes drew Daphnis aside and asked him if Chloe was a virgin. Daphnis swore that nothing had taken place between them but kisses and vows of fidelity; and Dionysophanes, who was delighted to hear of their compact, made them sit down to the feast.

It was now possible for everyone to see what beauty was like when enhanced by finery; for when Chloe was dressed and had braided up her hair and washed her face, she seemed to everyone so much more beautiful that even Daphnis hardly recognized her, and even without the tokens you would have

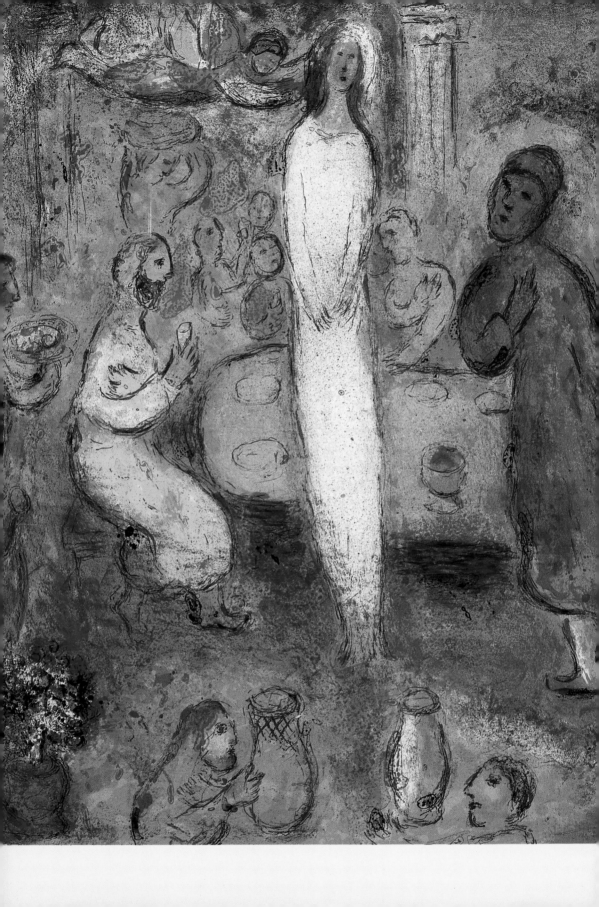

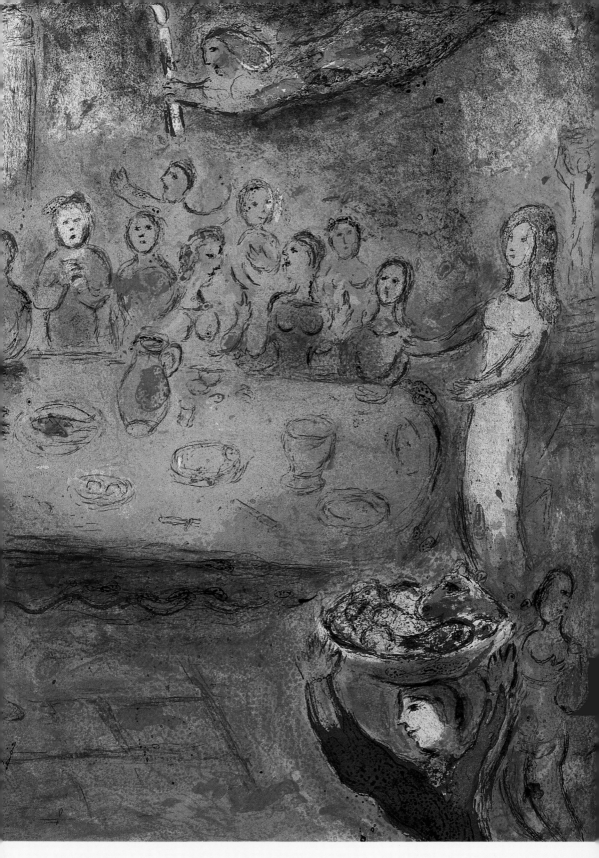

Megacles Recognizes His Daughter

sworn that Dryas was not the father of a girl like that. Still, he was there too, enjoying the feast with Nape and sharing a private couch with Lamon and Myrtale.

On the days that followed more sacrifices were made and more bowlfuls of wine were mixed. Chloe, like Daphnis, presented her old possessions as thank-offerings – her Pan-pipe, her knapsack, her fawn-skin and her milk-pails. She also poured some wine into the spring in the cave, bacause she had been nursed beside it, and also because she had washed in it so often. She even placed a wreath on the grave of the ewe, when Dryas had pointed it out to her. Then she, like Daphnis, piped some music to her flock; and when she had finished piping, she prayed to the goddesses that the parents who had exposed her might turn out to be rich enough for her to marry Daphnis.

When they had had enough of feasting in the fields, they decided to go into Mytilene and look for Chloe's parents and not delay the wedding any longer. So they prepared for an early start, and gave Dryas another three thousand drachmas. To Lamon they gave harvesting and fruit-picking rights over half the estate, possession of the goats together with the goatherds, four yoke of oxen, some winter clothes, and freedom for his wife. After that they drove off to Mytilene in a splendid procession of carriages and horses.

It was dark when they arrived, so the citizens were not immediately aware of it; but next day a crowd of men and women collected at their door. The men congratulated Dionysophanes on having found a son, all the more so when they saw Daphnis's beauty; and the women complimented Cleariste on having acquired a son and daughter-in-law simultaneously. For Chloe's beauty astonished even them and gained an unrivalled reputation. In fact the whole city developed a craving to see the boy and girl, and were already predicting that the marriage would be a happy one. They prayed that the girl's birth might turn out to be

worthy of her beauty; and many a rich lady begged the gods to
let it be supposed that she was the mother of this beautiful girl.

After much anxious thought Dionysophanes fell into a deep
sleep and had a dream like this. He dreamed that the Nymphs
were begging Love to consent at last to the marriage; and that
Love, after unstringing his little bow and putting away his
quiver, commanded him to invite all the leading citizens of
Mytilene to a feast, and at the moment when he filled the last
bowl of wine to show each of them the tokens. After that he was
to arrange for the wedding-song to be sung.

On seeing and hearing this he got up very early and ordered
a splendid banquet to be prepared, including every delicacy
that could be found on land or in the sea, in marshes or in rivers.
Then he invited all the leading citizens of Mytilene to be his
guests.

When it was already dark, and the bowl from which it is
usual to pour a libation to Hermes had been filled with wine, a
servant brought in the tokens on a silver tray and started carry-
ing them round from left to right and showing them to all the
guests. At first no one recognized them; but when they were
shown to a certain Megacles, who because of his great age was sit-
ting in the place of honour and was therefore the last to see
them, he cried out in a voice as powerful as any young man's:

'What's this I see? What has become of you, my little daugh-
ter? Are you still alive – or has some shepherd merely found
these things and brought them here? Please tell me,
Dionysophanes – where did you get my child's tokens from?
Now that you've found Daphnis, don't grudge me a chance of
finding something too!'

But Dionysophanes insisted on his first describing the ex-
posure, so without dropping his voice Megacles went on to say:

'I used to have very little money to live on, for what I had I
spent on fitting out warships and producing plays. While I was

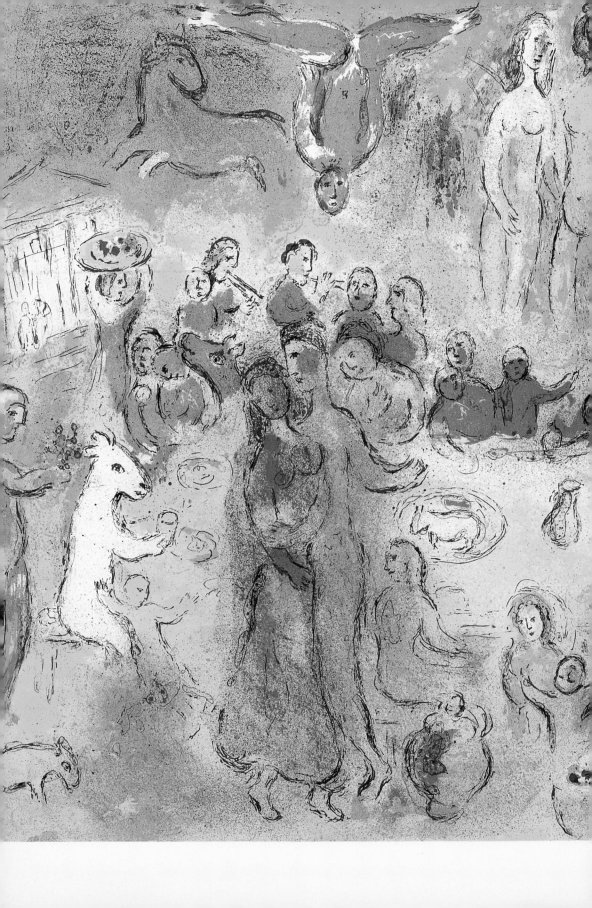

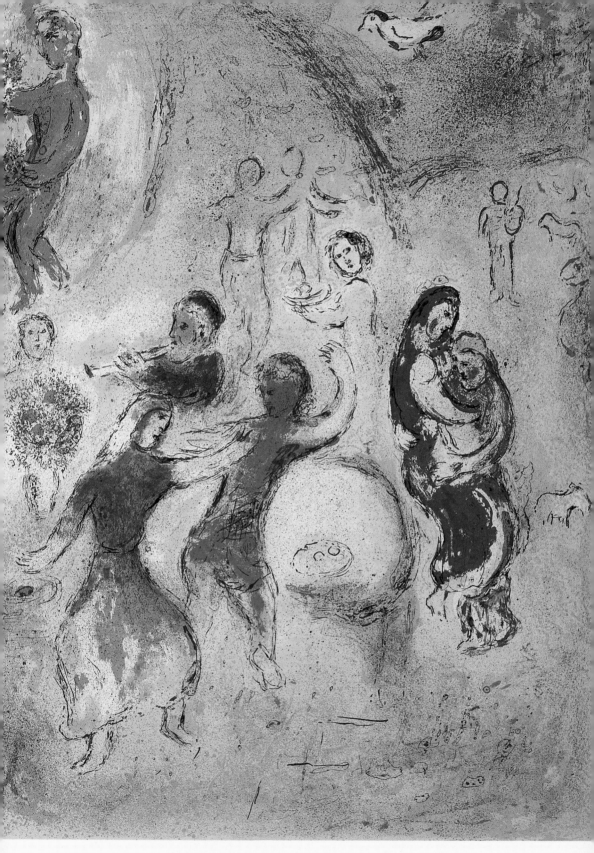

The Wedding-Feast in the Shrine of the Nymphs

in these circumstances, a little daughter was born to me. Feeling reluctant to bring her up in poverty, I supplied her with these tokens and exposed her, knowing that many people are only too glad to become fathers even by this method. So the baby was exposed in a cave of the Nymphs and left in their care; whereupon I began to grow richer every day – now that I had no heir. For since then I've not succeeded in producing a child of any sort, even a daughter. In fact the gods seem to be making fun of me, for they send me dreams at night which show that I'm going to become a father – by a ewe!'

Dionysophanes cried out even more loudly than Megacles had done, and jumping up he led in Chloe, very beautifully dressed, and said:

'Here's the baby that you exposed! By the mercy of providence a ewe nursed this girl of yours, just as a she-goat nursed my Daphnis. Take your tokens and your daughter – and when you've done so, give her back to me as a bride for Daphnis. We exposed them both – we've found them both! Both of them were looked after by Pan, and the Nymphs, and Love!'

Megacles applauded this proposal, and sent for Rhode, his wife, and clasped Chloe to his bosom. Then they all stayed there for the night; for Daphnis swore that he would not let anyone take Chloe away from him – not even her own father.

Next day, by common consent they drove back into the country; for Daphnis and Chloe were very anxious to do so, as they could not bear living in town. It was their idea too that their wedding should be a pastoral affair. So they went to Lamon's cottage, where they introduced Dryas to Megacles and presented Nape to Rhode. Then they started making preparations for the wedding-feast. And so in the presence of the Nymphs her father gave Chloe away, and along with many other things presented the tokens as thank-offerings, and gave Dryas what he needed to make up a total of ten thousand drachmas.

And there in front of the cave, as the weather was fine, Dionysophanes had couches of green leaves heaped up, and after inviting all the villagers to lie on them he entertained them lavishly. Lamon and Myrtale were there, and Dryas and Nape, and Dorcon's relations, and Philetas and his sons, and Chromis and Lycaenion. Not even Lampis was missing, for he had been judged worthy of forgiveness.

As was only to be expected with guests like these, everything that took place was of an agricultural and rustic nature. One man sang the kind of songs that reapers sing, another cracked the sort of jokes that are heard round the wine-press. Philetas played his pipe; Lampis played a flute; Dryas and Lamon danced; Chloe and Daphnis kissed one another. Even the goats were there, grazing close by as if they too were taking part in the feast. The visitors from town did not find this altogether pleasant; but Daphnis called to some of the goats by name, and fed them with green leaves, and seized them by the horns and kissed them.

And it was not only then that they behaved like this, for as long as they lived they spent most of their time in pastoral pursuits, worshipping the Nymphs and Pan and Love as their gods, possessing a great many flocks of sheep and goats, and thinking that fruit and milk made a most delicious diet. Moreover, when they had a baby boy, they put him out to nurse with a she-goat; and when a little daughter was born to them next, they made her suck away at the teat of a ewe. And they called him Philopoimen, or Lover-of-flocks, and her Agelaia, or Lover-of-herds. Thus they and this way of life grew old together.

They also decorated the cave and set up images in it, and consecrated an altar to Love the Shepherd, and gave Pan a temple to live in instead of the pine, calling him Pan the Warrior.

But it was only later that they did these things and invented these names. Now, when night fell, all the guests escorted them

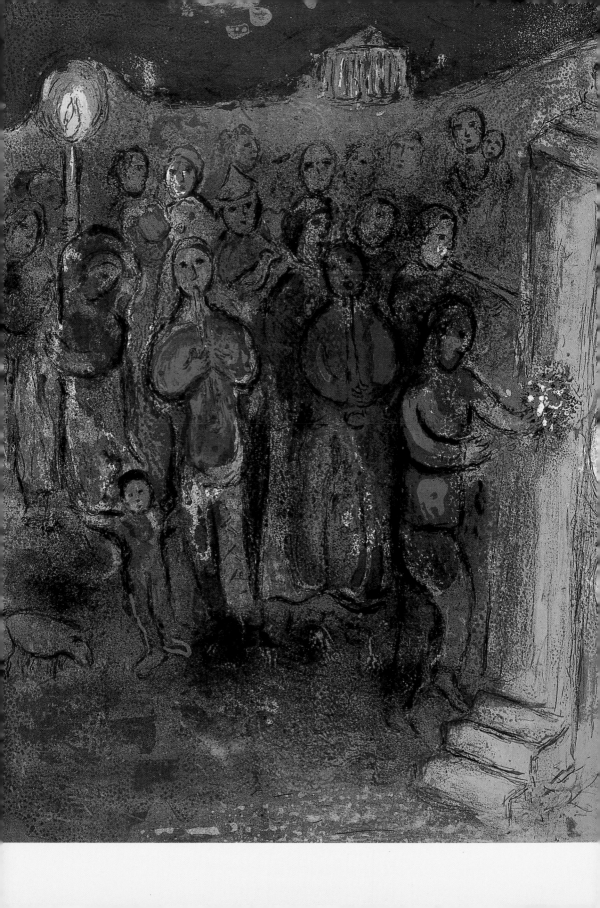

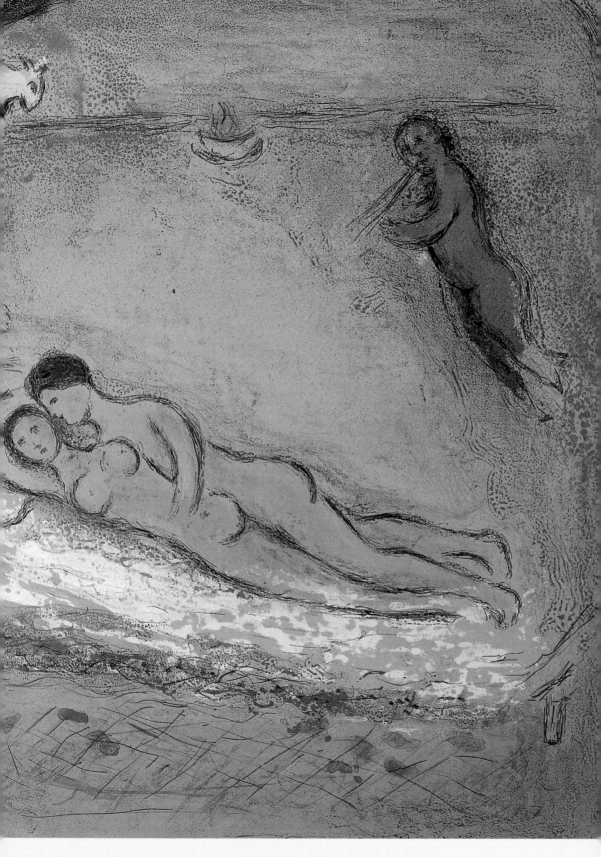

The Wedding Night

to the bridal chamber, some playing Pan-pipes, some playing flutes, and some holding up great torches. When they were near the door, the peasants began to sing in harsh grating voices as if they were breaking the soil with hoes instead of singing a wedding-song. But Daphnis and Chloe lay down naked together, and began to embrace and kiss one another; and for all the sleep they got that night they might as well have been owls. For Daphnis did some of the things that Lycaenion had taught him; and then for the first time Chloe realized that what had taken place on the edge of the wood had been nothing but childish play.

The original colour lithographs by MARC CHAGALL
were published in 1961 by Editions VERVE-Tériade Editeur,
Paris, in an edition of 250.
The reproductions in this book were from No. 158
in the Bavarian State Library, Munich.

Translation from the Greek by Paul Turner
© Paul Turner, 1956, 1968, 1989
This edition is published in association with Penguin Books Ltd.
The moral rights of the author have been asserted

Jacket: *Chloe's Kiss* (Detail)
Endpapers (front): *The Flute Player*, ink on paper 32.7 × 24.7 cm
Private collection, Berne
Endpapers (back): *The Pair*, ink on paper 64.5 × 49.5 cm
Private collection, Berne

Distributed in continental Europe by Prestel-Verlag
Verlegerdienst München GmbH & Co. KG, Gutenbergstraße 1, 82205 Gilching, Germany
Tel. (81 05) 38 81 17; Fax (81 05) 38 81 00

Distributed in the USA and Canada on behalf of Prestel
by te Neues Publishing Company,
16 West 22nd Street, New York, NY 10010, USA
Tel. (2 12) 6 27 90 90; Fax (2 12) 6 27 95 11

Distributed in Japan on behalf of Prestel
by YOHAN Western Publications Distribution Agency,
14-9 Okubo 3-chome, Shinjuku-ku, Tokyo 169, Japan
Tel. (3) 32 08 01 81; Fax (3) 32 09 02 88

Distributed in the United Kingdom, Ireland,
and all remaining countries on behalf of Prestel by
Thames & Hudson Limited, 30-34 Bloomsbury Street, London WC 1 B 3 QP, England
Tel. (71) 6 36 54 88; Fax (71) 6 36 16 95

Colour photography by Jean-Marie Bottequin, Munich
Colour separations by Osiris, Munich
Typesetting by Reinhard Amann, Aichstetten
Typeface: Baskerville
Printed and bound by Passavia Druckerei GmbH, Passau

Printed in Germany

ISBN 3-7973-1373-8